DAVID

DAVID

MICHELANGELO

Photographs by Aurelio Amendola

Text by Antonio Paolucci

Royal Academy of Arts

ORIGINAL ITALIAN EDITION
Copyright © 2002 Federico Motta Editore SpA, Milan
Copyright for the photographs © 2002 Aurelio Amendola

ENGLISH-LANGUAGE EDITION
Copyright © 2006 Royal Academy of Arts, London
Translation from the Italian: Translate-A-Book, Oxford
Typography: Isambard Thomas, London

British Library Cataloguing-in-Publication Data
A catalogue record for this book is available from
the British Library

Hardback
ISBN 10: 1-903973-99-6
ISBN 13: 978-1-903973-998

Distributed outside the United States and Canada
by Thames & Hudson Ltd, London

Distributed in the United States and Canada
by Harry N. Abrams, Inc., New York

Printed in Milan by Arti Grafiche Motta

PHOTOGRAPHIC ACKNOWLEDGEMENTS

Archivio Federico Motta Editore, Milan

Gabinetto Fotografico della Soprintendenza per il
Patrimonio Storico, Artistico e Demoetnoantropologico
di Firenze, Pistoia e Prato, Florence

Scala Istituto Fotografico Editoriale SpA, Antella (FI)

Reproductions from the Soprintendenze by courtesy of
the Ministero per i Beni e le Attività Culturali

Michelangelo's *David*: from Symbol to Myth

ANTONIO PAOLUCCI

Fig. 1 (*below*)
DONATELLO, *David.*
Marble. Bargello, Florence

Fig. 2 (*bottom*)
DONATELLO, *David.*
Bronze. Bargello, Florence

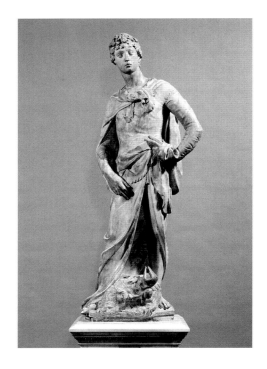

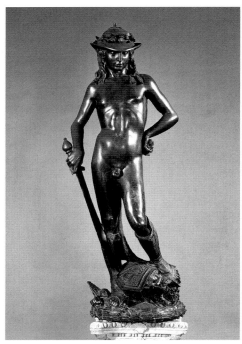

Underlying Michelangelo's *David* is one of the most enthralling of Bible stories, a tale as full of suspense and drama as any action movie. To summarise: the Israelite army led by King Saul comes face to face with the Philistines for the decisive battle. Out of the enemy camp of the Philistines a giant steps forward,

named Goliath, of Gath, whose height was six cubits and a span. And he had an helmet of brass upon his head, and he was armed with a coat of mail; and the weight of the coat was five thousand shekels of brass (1 Samuel XVII, 4).

The giant challenges the army of Israel to a single combat. His proposal is direct and brutal:

choose you a man for you, and let him come down to me. If he be able to fight with me, and to kill me, then will we be your servants: but if I prevail against him, and kill him, then shall ye be our servants, and serve us (1 Samuel XVII, 9).

The champion of the Israelites is young David, a shepherd, who has no practice in using weapons, and who has demonstrated his courage so far by slaying a bear and a lion which attacked his flock, but the Lord is with him and has chosen him as the King of Israel. A duel follows. David rejects the armour and heavy weapons King Saul has given him, takes a stick, sling and five polished stones and faces the giant Goliath. In the words of the Bible:

And the Philistine came on and drew near unto David: and the man that bare the shield went before him. And when the Philistine looked about, and saw David, he disdained him: for he was but a youth, and ruddy, and of a fair countenance. And the Philistine said unto David, Am I a dog, that thou comest to me with staves? And the Philistine cursed David by his gods. And the Philistine said to David, Come to me, and I will give thy flesh unto the fowls of the air and to the beasts of the field. Then said David to the Philistine, Thou comest to me with a sword, and with a spear, and with a shield; but I come to thee in the name of the Lord of hosts, the God of the armies of Israel, whom thou hast defied. This day will the Lord deliver thee into mine hand, and I will smite thee, and take thine head from thee; and I will give the carcases of the host of the Philistines this day unto the fowls of the air, and to the wild beasts of the earth; that all the earth may know that there is a God in Israel. And all this assembly shall know that the Lord saveth not with sword and spear: for the battle is the Lord's and he will give you into our hands. And it came to pass, when the Philistine arose and came and drew nigh to meet David, that David hasted, and ran toward the army to meet the Philistine. And David put his hand in his bag and took thence a stone, and slang it, and smote the Philistine in his forehead, that the stone sunk into his forehead, and he fell upon his face to the earth. So David prevailed over the Philistine with a sling and with a stone, and smote the Philistine, and slew him; but there was no sword in the hand of David (I Samuel XVII, 41–51).

The biblical account is riveting on account of its dazzling, almost tangible realism. Everything is played out in a swift and cruel scenario stripped of all but essentials. First we have the contrast between the blond adolescent and the formidable armoured giant, then the routine insults and finally the victor's shot with the sling and the wild leap forward, like that of a young leopard. This savage sequence culminates in the image of David who, treading the corpse of his conquered enemy, severs the head from the torso. Striking as are both the literary appeal and figurative thrust of the biblical account, the moral and religious message conveyed by the episode is no less remarkable. David triumphs because he is the Lord's sling, and because Justice and Virtue are on his side. God has placed Goliath in his hands to demonstrate that 'the Lord saveth not with sword and spear'.

The image of David, conqueror of the giant Goliath, became for Florence the symbol of republican liberty, which was protected by God and which no enemy would ever be able to overthrow. The most successful interpreter of this 'political' reading of the figure of David was Donatello, in the fifteenth century. It is widely recognised that only Donatello, as Giorgio Vasari tells us, can be considered the true artistic precursor of Michelangelo. It is therefore worth considering Donatello's two statues of David (one

Fig. 3 (*top*)
VERROCCHIO, *David*.
Bronze, Bargello, Florence

Fig. 4 (*middle*)
The *ringhiera* of the Palazzo Vecchio with the copy of *David*, copy of *Judith*, and *Hercules and Cacus* by Baccio Bandinelli

Fig. 5 (*bottom*)
DONATELLO, *Judith*.
Museo di Palazzo Vecchio, Florence

in marble, the other in bronze, both now in the Bargello), for Michelangelo certainly had these in mind when he began his own colossal figure. The marble *David* of Donatello (Fig. 1) is documented in 1416 in the Palazzo Vecchio, in the so-called Sala dell'Orologio. The work's symbolic meaning was underscored by a Latin inscription, today lost, which proclaimed that God would protect the valiant who, like David, fight for their country. Donatello's hero gazes at the viewer as if he were sitting for a portrait after victory. His left hand is poised boldly on his hip, while in his right he bears the sling. At the young duellist's feet lies Goliath's severed head, displayed like a macabre trophy. The stone which caused the giant's death can still be seen, driven into his forehead. Donatello's sculpture is a dense concentration of pent-up energy, the spiritual dimension eclipsing the physical. It is like a coiled spring on the point of release. The slender body sways slightly, with the supple grace of a lingering Gothic tradition, but the face betrays the rational determination of a Renaissance hero, who is master of his own destiny, the measure of all things. In what follows it will become clear that Michelangelo also wished to portray his David in terms of a contained energy and watchful spiritual tension.

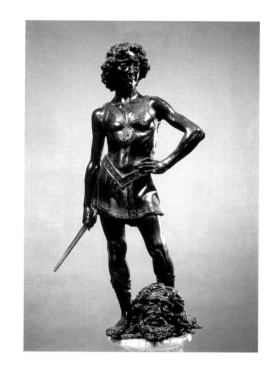

Donatello's bronze *David* (Fig. 2), which once stood in the courtyard of the Palazzo Medici, and subsequently in the Palazzo Vecchio, was executed in about 1433. It offers us a different and subtler interpretation of the biblical episode. David is very young, almost a boy, and he is nude, as Michelangelo's hero was to be. Under the victor's feet, resting on a laurel wreath, is the head of his vanquished enemy. The young warrior stands pensive, his triumph devoid of pride or joy. In one hand he clasps the stone and in the other the sword, symbols of his victory, but his slightly bowed face, cast in shadow by an odd, wide-brimmed hat, appears tinged with melancholy.

The young David is perhaps pondering the Latin inscription which was once carved (if the base was stone...) on the base, stating the inscrutable fate of divine action, capable of transforming a boy's frailty and inexperience into invincible strength: 'The victor is whosoever defends his country/ Divine power shatters the enemy's wrath/ Behold, a boy overcomes the great tyrant/ Conquer O citizens!'

No account of the tradition of Florentine statues of David which preceded Michelangelo's can end without mentioning Verrocchio's bronze, today housed in the Bargello. Cast for the Medici family in the early 1460s and then transferred to the entrance of the Sala dei Gigli in the Palazzo Vecchio, Verrocchio's *David* (Fig. 3) is a masterpiece of throbbing vitality. It is the physical and psychological immediacy of the scene in question rather than the moral and symbolic implications that appear to attract the sculptor. The biblical hero is a youthful gladiator, his taut muscles visible below the surface; he has just struck down his opponent and now, rapt and tense, awaits his well-deserved triumph.

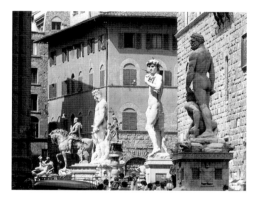

Before entering into details of Michelangelo's *David*, we must imagine ourselves in the Piazza della Signoria where the sculpture remained for nearly four centuries, from June 1504 to the summer of 1873, and where Luigi Arrighetti's copy, completed in 1910, now stands in its place.

The Piazza della Signoria is of importance because its symbolic layout can still be deciphered, thus allowing us to understand the meaning of Michelangelo's masterpiece.

Even the most casual tourist cannot fail to notice that some of the famous statues placed in the piazza (Fig. 4) and in the Loggia dei Lanzi stand for atrocious scenes of violence and death. These are crimes of necessity, justified by morality and reasons of State. They are severe and persuasive political messages, addressed to the public at large.

One episode of savage revenge is Donatello's bronze *Judith* (Fig. 5), today replaced by a copy, in the square in front of the Palazzo Vecchio. The biblical heroine is shown in

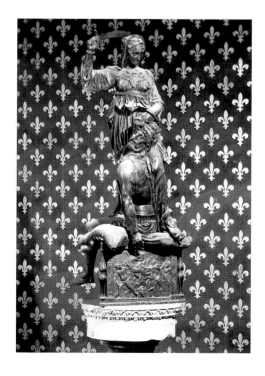

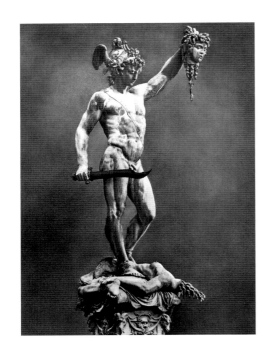

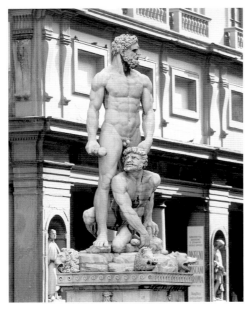

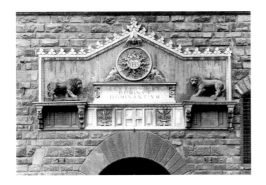

the act of decapitating her enemy, the general Holofernes, after winning his trust and satisfying his sexual desires. The Latin inscription running round the marble base is of a dreadful clarity: *exemplum salutis pubblicae*, an example of public salvation, tantamount to stating that anything is allowed – even deceit, dishonourable acts on one's own body or murder – if the freedom of one's country is at stake. For nine years, from 1495 to 1504, the *Judith* held the position now occupied by the *David* on the left of the entrance to the Palazzo Vecchio. It was later placed in the Loggia dei Lanzi as a companion piece to Benvenuto Cellini's *Perseus* (Fig. 6). Begun in 1554, Perseus, with his matter-of-fact holding up of Medusa's severed head, appears an even more savage executioner than Judith.

A sculptural group by Baccio Bandinelli also shows a murder, in the guise of Hercules slaying Cacus (Fig. 7). In 1533 at the behest of Duke Alessandro de' Medici it was placed to the right of the main entrance to the Palazzo Vecchio as a pendant to Michelangelo's *David*.

All the sculptures mentioned thus far occupy a prominent and didactically effective position in the piazza, their message quite clear. Old Testament and Classical myths furnish examples and precepts which are both highly topical and universally relevant: the victory of Good over Evil, virtuous strength (Hercules, Perseus) which triumphs over disorder and violence, and God who is transformed into the sword and sling of justice (Judith, David) when upright conduct is offended, and liberty threatened.

The symbolic layout which dominates the entrance to the Palazzo Vecchio, seat of Florentine political power, still appears extraordinarily effective today. Michelangelo's *David* symbolises the hand of God which will protect Florence from all her enemies – just as it protected Israel from the Philistines and Goliath – provided that Virtue and Rectitude guide her administrators. Hercules who slays the evil Cacus stands for the inflexible rigour of public authority, rightly severe in the face of disorder and violence. The statues of David and Hercules, placed to the left and right of the main entrance to the Palazzo Vecchio, are the watchmen and guarantors of 'Buon Governo'. As the 'Dioscuri' of the city, its protective guardian angels, they symbolise the history and fate of Florence.

To complete this symbolic framework, on the façade of the Palazzo Vecchio and watched over by the Dioscuri is the monogram of Christ flanked by two lions (Fig. 8), with the famous inscription attributed to Savonarola, placed there in 1529, in the dying days of the Florentine Republic: *Rex Regum et Dominus Dominantium*, meaning that Christ the Redeemer, King of Kings and Lord of Lords, should be at the pinnacle of all worldly power and the guiding star of all political action.

It is necessary to have some understanding of the symbolic system governing the Piazza della Signoria – the real political theatre of civic history and identity – to account for the placement and even the very form of the *David*. When Michelangelo's statue was placed in the square in front of the Palazzo Vecchio, Florence was a Republic. The Medici had been expelled in 1494 but in the turbulent political climate of those years, their return seemed possible at any moment. The Gonfaloniere Pier Soderini, together with the notables of the city, probably felt that never as in those years was Florence itself so like David: encircled and menaced by enemies of greatly superior strength, yet the guardian of lawfulness and freedom, proud of its autonomy and determined to defend it. In this sense it was, like David, protected by God.

If this is true then the *David* (erected on a site of such symbolic consequence) must express both calm and strength. He cannot be a meek adolescent but a young man at the peak of his physical might. He must appear grand and imposing beyond mere physical stature. He must resemble Hercules, the symbol of invincible and virtuous strength (Fig. 9). The citizens must perceive him as a colossus and a giant. The statue has to be the visible emblem of Republican power which is mighty because it is watched over by God.

Fig. 9 (*top*)
NICOLA PISANO, *Strength in the Form of Hercules*.
Baptistery pulpit, Pisa

Fig. 10 (*middle*)
MICHELANGELO, *La Pietà*.
St Peter's, Vatican

Fig. 11 (*bottom*)
MICHELANGELO, *Bacchus*.
Bargello, Florence

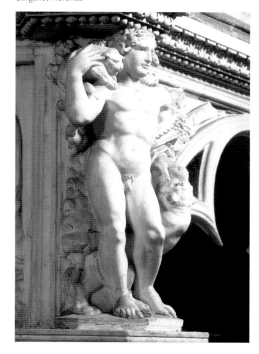

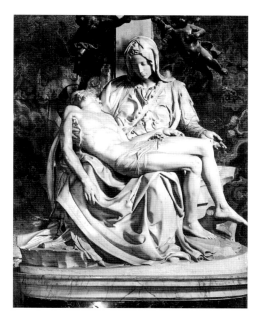

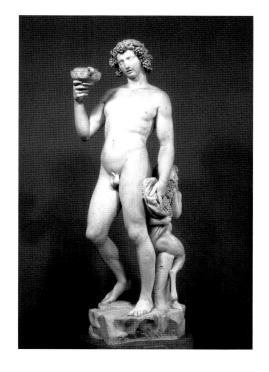

When Michelangelo Buonarroti began work on the *David* (the official commission is dated 16 August 1501) he was barely twenty-six, but already an artist with an established reputation. His *Pietà* at St Peter's in Rome (Fig. 10), executed for Jean Villiers de La Grolais, had caused a sensation worldwide. From 1496 to 1497 he had grappled with the theme of the standing male nude, the principal subject-matter of great Classical statuary. The result is the *Bacchus*, now in the Bargello (Fig. 11), which was sculpted for Cardinal Raffaele Riario and which then passed into the hands of the banker Jacopo Galli: at once the most classicising of Michelangelo's statues but also constituting the first 'modern' nude in the history of art.

Whereas with the *Bacchus* he had demonstrated his ability to engage with the Antique, in executing the *David* Michelangelo goes beyond such emulation. The sculpture surpasses Classical models and the masters of antiquity. He creates a piece of sculpture which has 'without any doubt ... eclipsed all other statues, whether ancient or modern, Greek or Roman'. Such is the opinion of Giorgio Vasari, who, to reinforce the concept, says that the *David* sums up and epitomises the very idea of a statue: 'Someone who has seen it once need never wish to see anything by any other sculptor, living or dead.'

Now that centuries have passed, it would seem that the extravagant praise that Vasari used simply as a rhetorical flourish to express his admiration is today taken literally by most of the tourists who visit the Galleria dell'Accademia. They come to see the *David* and virtually nothing else, convinced that once they have seen it they have completed their visit. But we shall return to the modern 'myth' of the *David* later.

The history of the *David* as a sculpture began in the *magazzini* of the Opera di Santa Maria del Fiore. At the outset there was a block of marble, colossal, though of mediocre quality, from the quarry of Fantiscritti, near Carrara. Other sculptors before Buonarroti (Agostino di Duccio in 1464, Bernardo Rossellino in 1476) had attempted to work the block only to abandon it in a rough-hewn state. Though it is somewhat controversial, and cannot be proved, the theory that the present shape of the statue was in part determined by these earlier workings cannot be discounted. In spite of these considerable disadvantages (the poor quality of the marble; a block which had already been tampered with) the twenty-six-year-old Michelangelo accepted the commission, completing it within just three years.

Florentine sources trace in detail the laborious transit of 'the Giant' from the Opera del Duomo to the Piazza della Signoria and to the *ringhiera* (the dais) in front of the Palazzo Vecchio. The undertaking took from 14 May to 8 June 1504. A complicated hoist was devised by Antonio da Sangallo, Cronaca (Simone del Pollaiuolo), Baccio d'Agnolo and Bernardo del Cecca. Donatello's *Judith* had to be removed, given the intention to replace it with the *David* in the symbolic layout of the piazza.

On 11 June it was decided that a marble base designed by Antonio da Sangallo and Simone del Pollaiuolo should be executed. Michelangelo spent the months of July and August putting the final touches to the sculpture. It was then that the famous scene reported by Vasari occurred. The Gonfaloniere Pier Soderini, one day looking up at the statue while Michelangelo was at work, criticised David's nose which in his opinion had turned out 'too big'. To satisfy his distinguished critic, the artist took up his chisel and, pretending to rework the nose, dropped some marble dust he had picked up from the planks of the scaffolding. 'Then he looked down at the Gonfaloniere who was watching, and said: "Now look at it." "That's a great improvement," replied the Gonfaloniere. "Now you've really brought it to life." Then Michelangelo climbed down, laughing to himself and feeling sorry for those critics who will say anything, hoping to impress.' The conclusion of the episode and Michelangelo's smile provide the most apposite subtext on the incompetence of such uninformed and presumptuous art critics, common in all periods.

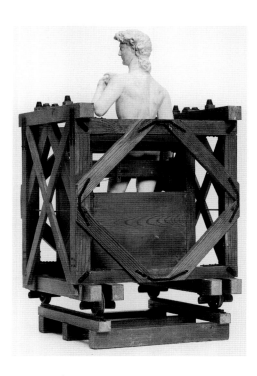

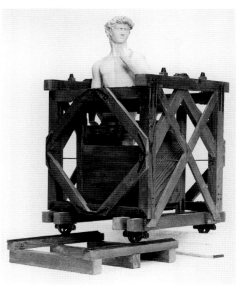

The *David* was unveiled to the citizens on 8 September, the Feast of the Virgin.
A few days earlier the artist had received the agreed payment of four hundred crowns
– a substantial sum, though not exceptional, considering the huge size of the sculpture
and the exhausting nature of the work over a period of three years. The installation of the
David on the *ringhiera* in front of the Palazzo Vecchio in place of the *Judith* came about
as the result of a commission during which there was some heated debate among the
foremost Florentine artists of those years, from Leonardo da Vinci to Botticelli, from
Giuliano da Sangallo to Piero di Cosimo and Filippino Lippi. The committee was
convened on 25 January 1504 when the sculpture was practically finished. Apart from
the eccentric proposal of the elderly Botticelli, who wished to see the *David* placed in
a prominent location near the cathedral, the argument centred around two proposals:
installation on the *ringhiera* in front of the Palazzo Vecchio in place of the *Judith* or in a
semi-covered site inside the Loggia dei Lanzi. The former proposal prevailed, partly
because Michelangelo himself preferred it. But the latter (advocated by Giuliano da
Sangallo and supported by Leonardo) was based on legitimate considerations from the
point of view of conservation. An interior location or semi-covered site was advisable
because 'of the imperfections of the marble, soft and brittle as it had become, having
been exposed to sun and rain'. Such was the opinion expressed by the highly
experienced expert Giuliano da Sangallo in the meeting of 25 January. Subsequent
events, culminating in the necessary transfer of the work in 1873, proved that his
reasoning was well founded.

The Florentines must have found that the *David*, unveiled on 8 September 1504,
looked similar to many of the statues of gods by Phidias and Praxiteles mentioned by
the writers of Classical antiquity. Standing high on a plinth, the statue, of impressive
dimensions (4.99 metres high), was almost blinding in the ivory-white splendour of
a nudity never before shown on so large a scale and so realistically. The biblical hero
wore a golden garland on his head, such as befits a victorious athlete, while the tree-
trunk and sling were highlighted in gold. In September of the year 1504 it must have
seemed to many that Florence had reached the zenith of its glorious artistic history.
At the foot of the 'Giant' the City of the Lily could see herself as the legitimate heir
to Athens and to ancient Rome.

The misadventures of the *David* began early on. In 1512 it was struck by lightning,
thereby suffering serious damage – which was destined to worsen as time passed –
to the stability of the base. In 1527, at the time of the popular riots attending the
expulsion of the Medici and the ephemeral return of the democratic Republic, the
left arm of the statue was smashed. The restoration, with the pieces which had
fortunately survived the break, was financed by Duke Cosimo in 1543. In the meantime
the prescriptions of the Catholic Counter-Reformation had resulted in the partial
covering up of the *David*'s nudity. In 1545 (according to evidence from Pietro Aretino)
a metal loincloth suggesting foliage was attached to the hips of the statue to conceal
the genitals of the biblical hero.

In the nineteenth century it became increasingly evident that, in view of
the precarious state of conservation of Michelangelo's masterpiece, some intervention
would be required to guarantee the statue's survival. Restorations followed by Stefano
Ricci in 1813 and Aristodemo Costoli in 1843, but the results were considered inadequate
if not downright detrimental. The first to speak explicitly of the need to remove the *David*
was the great sculptor Lorenzo Bartolini in 1842, who was concerned that 'a thorough-
going conservation of the sublime statue of the *David*' should be carried out.

During the course of the nineteenth century various study committees were set up
in whose reports it was recognised that the sculpture was in poor condition and at risk
in its current position. Furthermore the surface was increasingly being worn away by the
effects of fluctuations in temperature and exposure to pollution.

At a certain point the possibility of transferring the statue to the inside of the Loggia dei Lanzi materialised, following a proposal from the court architect Pasquale Pocciante and prompted by the concern of the Grand Duke Leopold II. After more than three centuries there was talk once again in Florence of the decision advocated by Giuliano da Sangallo and Leonardo. A life-size plaster cast, made especially for the occasion, was exhibited inside the Loggia from June to October of 1854 so that public opinion could evaluate and decide. However, artists and intellectuals deemed the effect disappointing. 'The Giant' appeared diminished and constricted inside the Loggia. Unfavourably lit, the work did not stand out from the other statues and its singular grandeur failed to impress. The Grand Duke's idea was not taken up.

From 1860 to 1870 (years which saw Tuscany pass out of the control of the House of Lorraine, and the Unification of Italy, with Florence as capital) the debate on the ultimate fate of the *David* moved towards its resolution – the decision that was taken in 1872 by the last commission of experts presided over by Luigi Menabrea. It was irrevocably resolved to remove Buonarroti's masterpiece from the Piazza della Signoria forever and to give it an interior setting in the Galleria dell'Accademia.

Secured for hoisting in a wooden crate, a small model of which is preserved in the Museo di Casa Buonarroti (Figs. 12–13), the sculpture made its slow journey across the city from 30 July to 10 August 1873. Regrettably, the sixteenth-century base which, according to reports of the period, was in a lamentable condition, was lost when the statue was dismantled. At that time a particular climate prevailed in Florence. The year 1875 was approaching, the fourth centenary of Michelangelo's birth, and the city wished to honour its foremost artist by staging celebrations such as would never be repeated in its history. Events revolved round the Casa Buonarroti and the Galleria dell'Accademia, branching out into the Palazzo Vecchio, Santa Croce and the Archivio di Stato, where there were exhibitions of original manuscripts and drawings, vast displays of casts, as well as lectures, conferences and tributes from foreign academies, and the whole ephemeral ceremonial paraphernalia that customarily accompanies such anniversaries. Important scientific ventures were also organised. The edition of the *Lettere* edited by Gaetano Milanesi was a touchstone for all. The aim was to glorify Michelangelo, to make official the myth of the great patriotic and universal Florentine genius. But the intention on this occasion was also to affirm Florence's own supremacy. The city, humiliated and undermined by the transfer of the government and ministers to Rome, and oppressed by a serious economic crisis, attached great importance to reclaiming its role as the Italian capital of art and culture through Michelangelo's centenary – to this at least the city could aspire, seeing that it had been deprived of its other roles forever. Florence in 1875 was persuaded (or rather, forced) to make an important choice destined to weigh heavily in the future, whose effects, for good and ill, still resonate. The main event of 1875 was the presence of the *David* in the Accademia where 'the Giant' was exhibited in a temporary and precarious setting throughout the centenary celebrations.

It was not until 1882 that the sculpture found its final setting in the Accademia. The result, based on the design of the architect Emilio De Fabris, was astonishing and can be considered a masterpiece of nineteenth-century celebratory museography. The architect succeeded eminently in glorifying Michelangelo's most famous statue. The *David* was placed centrally in a vaulted exedra, towards the apse, almost as though it were the altar in a Catholic church. Bathed in light streaming in through windows in the dome, set apart in his disquieting beauty and almost transfigured beyond history, the biblical prophet, formerly the symbol of republican freedom, became the modern totem of universal artistic imagination: the most beautiful statue, and indeed the most beautiful man, in the world.

During the nineteenth and twentieth centuries the *David* inevitably assumed the role of supreme tourist icon in Florence. Reproduced in bronze (a copy by Clemente Papi), it was erected in the middle of the scenic *piazzale* overlooking the city, designed by

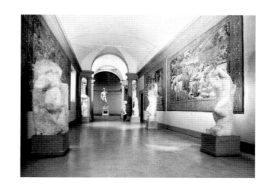

Giuseppe Poggi, and later renamed Piazzale Michelangelo; in 1910 it was reinstated as a copy by Luigi Arrighetti in the Piazza della Signoria. The sculpture of Buonarroti became the symbol and synonym of Florence throughout the world.

In 1909 the Sopraintendente, Corrado Ricci, was responsible for the final brilliant act in the mythicising of the *David*. A suitable context had to be found for the statue, isolated in the tribune designed by Emilio De Fabris. To lead visitors towards their viewing of the masterpiece, a grandiose preamble was required. And so Ricci removed Michelangelo's *Captives* – figures planned for the tomb of Julius II, which Michelangelo had left unfinished and which had been transformed into 'rustic' furnishings in accordance with mannerist taste – from the grotto of Buontalenti in the Boboli Gardens. Ricci placed them, together with the statue of St Matthew commissioned for Santa Maria del Fiore, also unfinished, to the right and left of the nave preceding the tribune, forming a sublime guard of honour.

Today the visitor who passes through the hall lined with the *Captives* and the *St Matthew* (the work known as the *Palestrina Pietà*, whose attribution is now debated, arrived only later) experiences an effect similar to that of going through a tunnel of compressed energy (Fig. 14). The spiritual force conveyed by these pieces of sculpture is so intense as to be almost tangible. At the end of the hall the *David* dominates the *Captives* like a banner above the waves in a stormy sea. It is a sculpture which exercises a kind of magnetic attraction on tourists from all over the world. More than a splendid masterpiece of the Italian Renaissance, the *David* of the Accademia is a metahistorical projection of ambiguous sexual attraction, an emotional overstatement, as it were, shrewdly exploited both by the culture industry and by tourist agencies.

The mythical transfiguration of the *David*, carried out so effectively between the nineteenth and twentieth centuries may account for the action of Pietro Cannata, a madman who struck the foot of the sculpture with a hammer in 1991. Fortunately the damage he caused was not irreparable.

This is the moment to examine the *David* closely, with the help of the marvellous photographic project carried out by Aurelio Amendola – the highest-quality and most striking documentation yet available. The statue is 4.99 metres high, although it would seem that the true figure is 5.17 metres according to findings of the recent study carried out by Professor Marc Levoy using laser-scanning technology. (For a view of the virtual reconstruction see the website www.graphics.stanford.edu.)

It is the equal in size of the 'Giants of Monte Cavallo' (Fig. 15), the *Dioscuri* in front of the Quirinale, with which Michelangelo was familiar and which he surpassed in style, together with the other monumental statues in Rome, as Vasari rightly states. The *David*'s present site in the tribune of De Fabris enhances the force of the concept: however, the awesome dimensions of every detail obscure, at least in part, what Vasari praised most in the statue, namely its elegant and exact rendition of human anatomy, the knowledge and 'grace' of the modelling, 'the ravishing line of the legs', 'the set and the slenderness of the godlike hips', 'the entire pose perfection'.

The principal merit of Amendola's photographic documentation consists in revealing the complete and harmonious grace that permeates the anatomy of the *David* and which had been shown by Buonarroti a few years earlier in the St Peter's *Pietà*.

The *David* is the victorious hero, the athlete of Florentine freedom, the Hercules of the myth and the gladiator of Israel. But David also exemplifies 'my cherished fancy which made art for me both idol and master', as Michelangelo was to acknowledge in a famous sonnet from his later years. The *David* is pure manly beauty which claims its rights, and at this point in Michelangelo's life, and in the evolution of his style, the subject occupies and dominates the artist's mind and guides his hands; an 'idol' and a 'master' indeed.

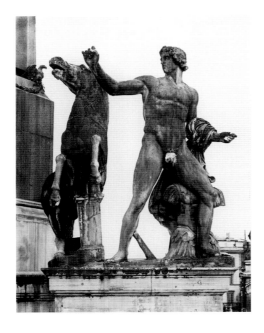

13

Michelangelo's statue is uncompromisingly nude, more so than Donatello's young warrior, who is clad in a wide-brimmed hat and leggings which conceal his pre-pubescent innocence. The *David*'s deliberately virile and proudly displayed nudity is the first and most significant of Michelangelo's departures from the customary iconography. The artist has chosen to tackle the Classical theme of the standing nude. His models are the great nudes of antiquity: Hercules and the Dioscuri. In this case, however, David's nudity is also a metaphor for his trusting abandonment to God's will. Michelangelo carries the meaning of the biblical account to its very limits. The hero of Israel was chosen by God as his instrument. He is the sling of God. He defies the enemy knowing that his unarmed nudity is nonetheless invincible because he is protected by the Almighty. In the Florentine tradition (as seen in the examples of Donatello and Verrocchio discussed above) David is shown after the duel, with Goliath's head displayed like a trophy of victory at his feet. But instead Michelangelo radically changes the schema, representing the moment of greatest physical and spiritual concentration that immediately precedes the attack. The whole body is in tension; the muscles drawing the limbs together, like a splendid and mighty sheath, are a 'killing' machine of taut energy, ready to spring. David's right hand, abnormally large, bulging with veins, grips the stone, which the sling, carried over the left shoulder, will launch to strike its fatal blow.

David's determination is concentrated in the face, the furrowed brow and in the gaze fixed on his opponent. His head is a conflation of Hellenistic beauty and the morality and spirituality of Judaeo-Christian culture. It is as if the features of the *Antinous* had been re-created in the manner of Donatello's *St George* (Fig. 16). The Donatello is the only Florentine sculpture of a similar subject (a vigilant young man, armed and portrayed in the magnificence of youth and strength) that Michelangelo can have had in mind, and that can be placed alongside the *David* (Fig. 17) without being dwarfed by the comparison.

The distinctive characteristic of all great works of art is to carry many meanings, to offer several layers of interpretation and to invite various interpretations. Annelio Amendola's comprehensive detailed photographic documentation reveals to us that the *David* of the Accademia is many things in one.

David is the hero to be equated with the demi-gods of myth, the prophet of Israel whom the Almighty holds in his hand. The *David* symbolises civic pride and the dignity and freedom of all humanity. It is both Florentine and universal. It is rock-like strength and poignant beauty. It is derived from the antique, and yet with the stone and with the sling, the figure comes straight into our own times.

It belongs to the 'modern' troubled consciousness of those who are aware of evil in the world and who know that it is our absolute duty to stand up to Goliath with courage. The 'monster' Goliath, albeit going by different names, is present in every period of history to obstruct the path of freedom and civilisation.

Fig. 16 (*below*)
DONATELLO, *St George*.
Bargello, Florence

Fig. 17
MICHELANGELO, *David*.
Galleria dell'Accademia, Florence

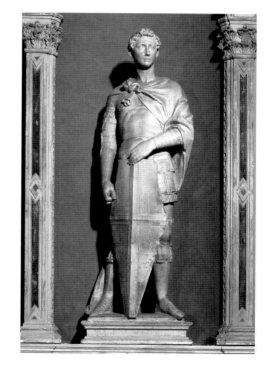

BIBLIOGRAPHY

The literature on Michelangelo's *David* is of course vast. The most frequently consulted texts on this occasion are the following: Giorgio Vasari, *Le Vite dei più eccellentie pittori ed architettori scritte da Giorgio Vasari pittore aretino*, with new annotations and comments by Gaetano Milanesi, Florence, 1906, vol. vii; Charles de Tolnay, *The Youth of Michelangelo*, Princeton, 1943; John Pope-Hennessy, *High Renaissance and Baroque Sculpture*, 1963, vol. ii; Stefano Corsi (ed.), *Michelangelo nell'Ottocento. Il centenario del 1875*, exh. cat., Casa Buonarroti, Milan, 1994; Franca Falletti (ed.), *The Accademia, Michelangelo, the Nineteenth Century*, in the series *The Place for David*, Livorno, 1997. (The reader is referred to this last text for all bibliographic and documentary references pertaining to the history of the *David* and its various sitings in Florence.)

The Images

AURELIO AMENDOLA

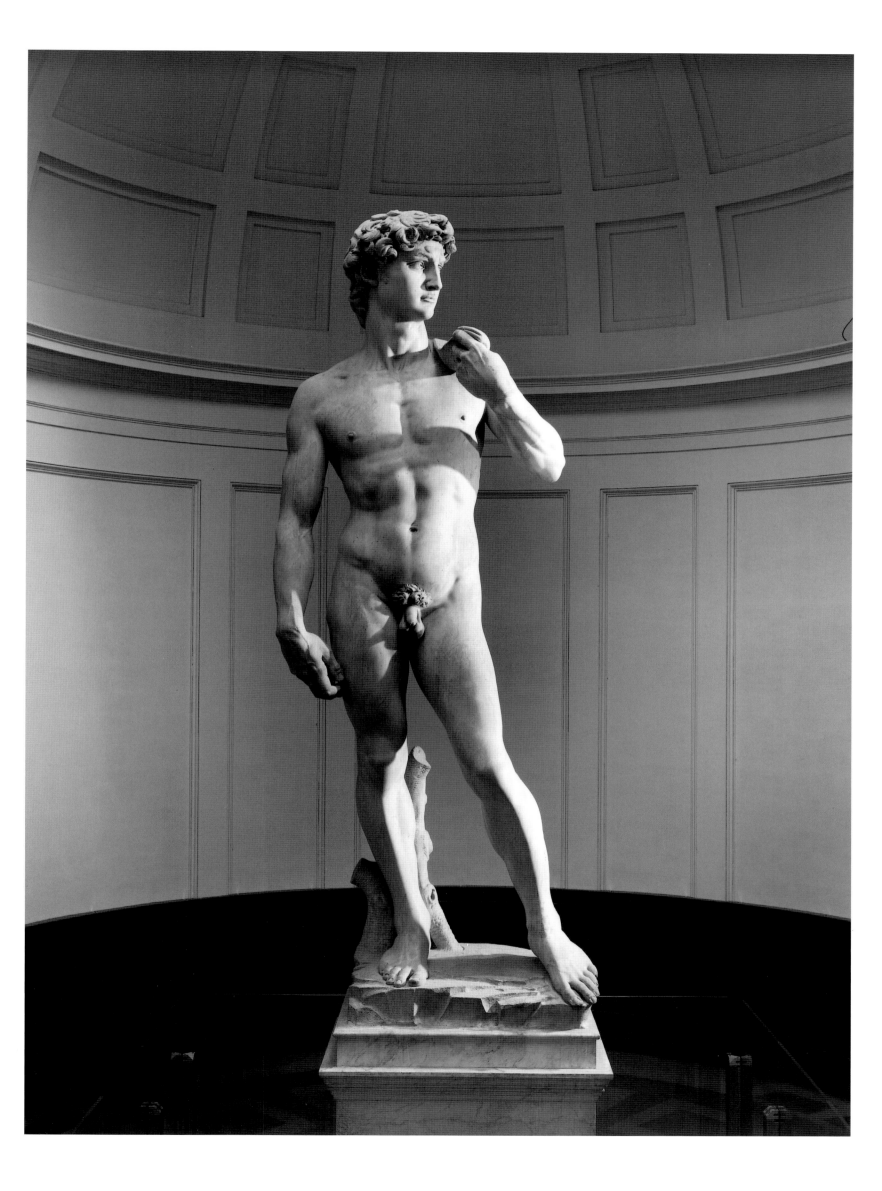

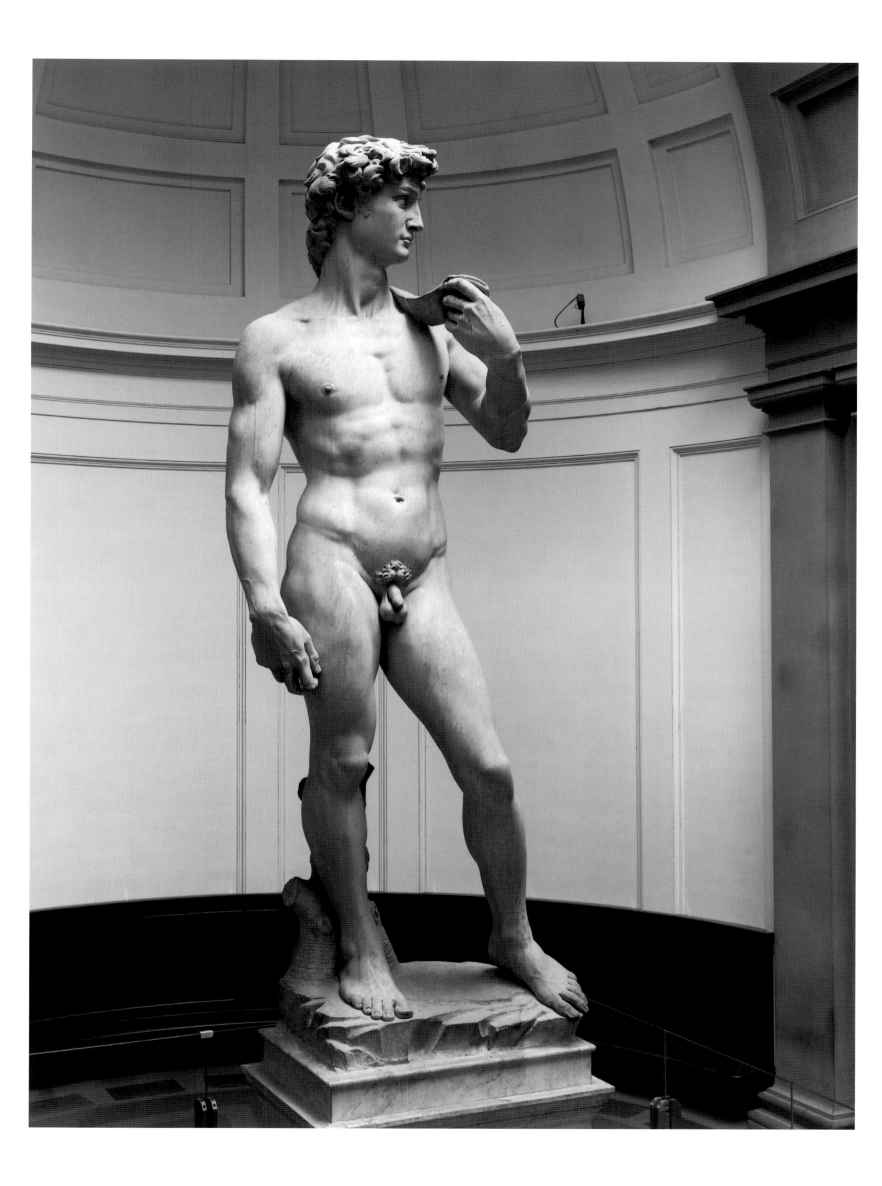

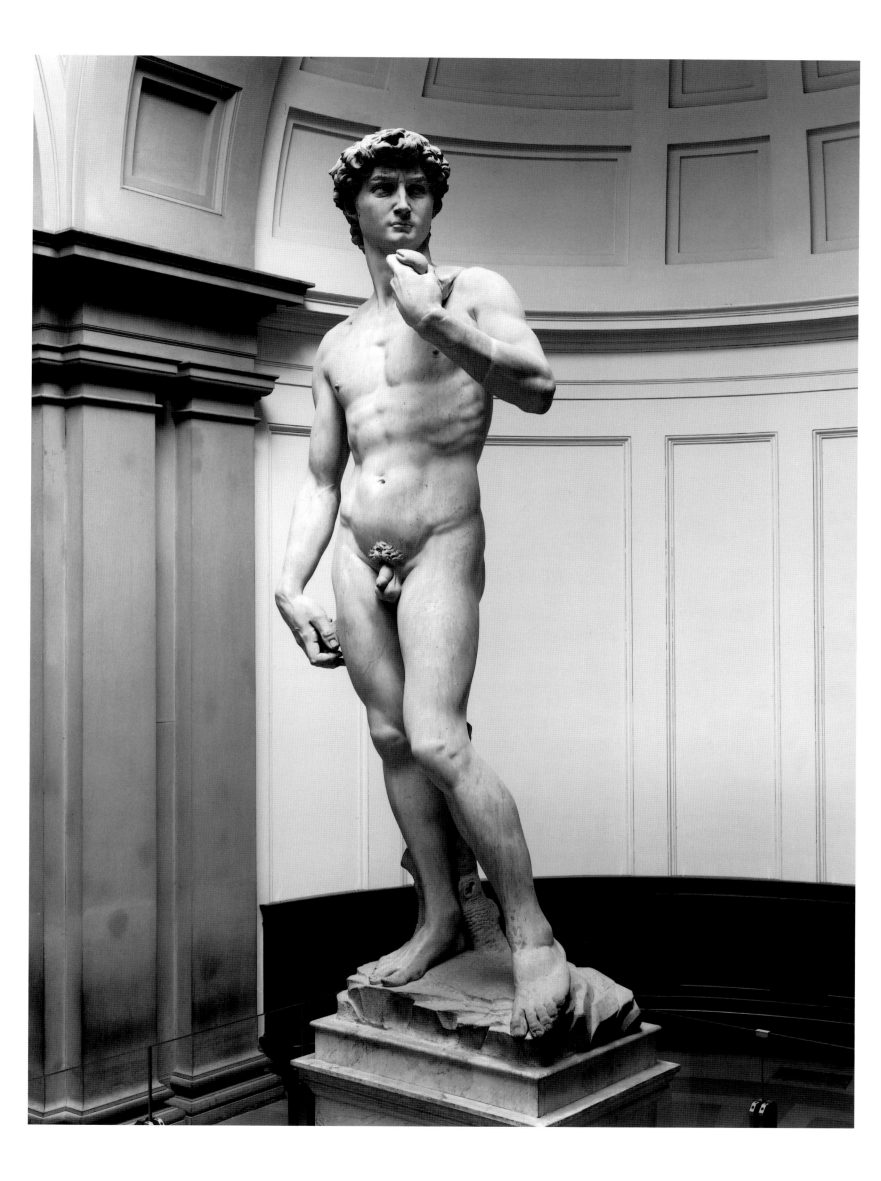

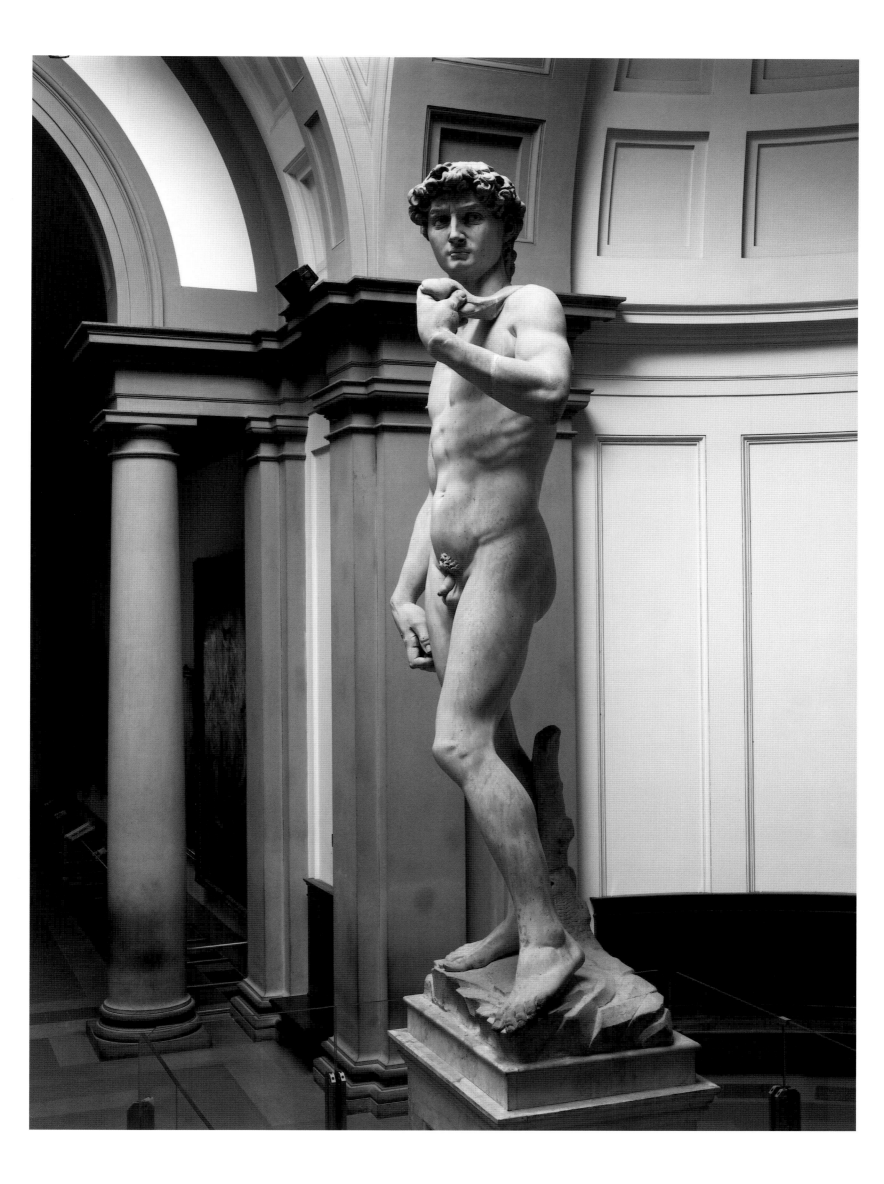

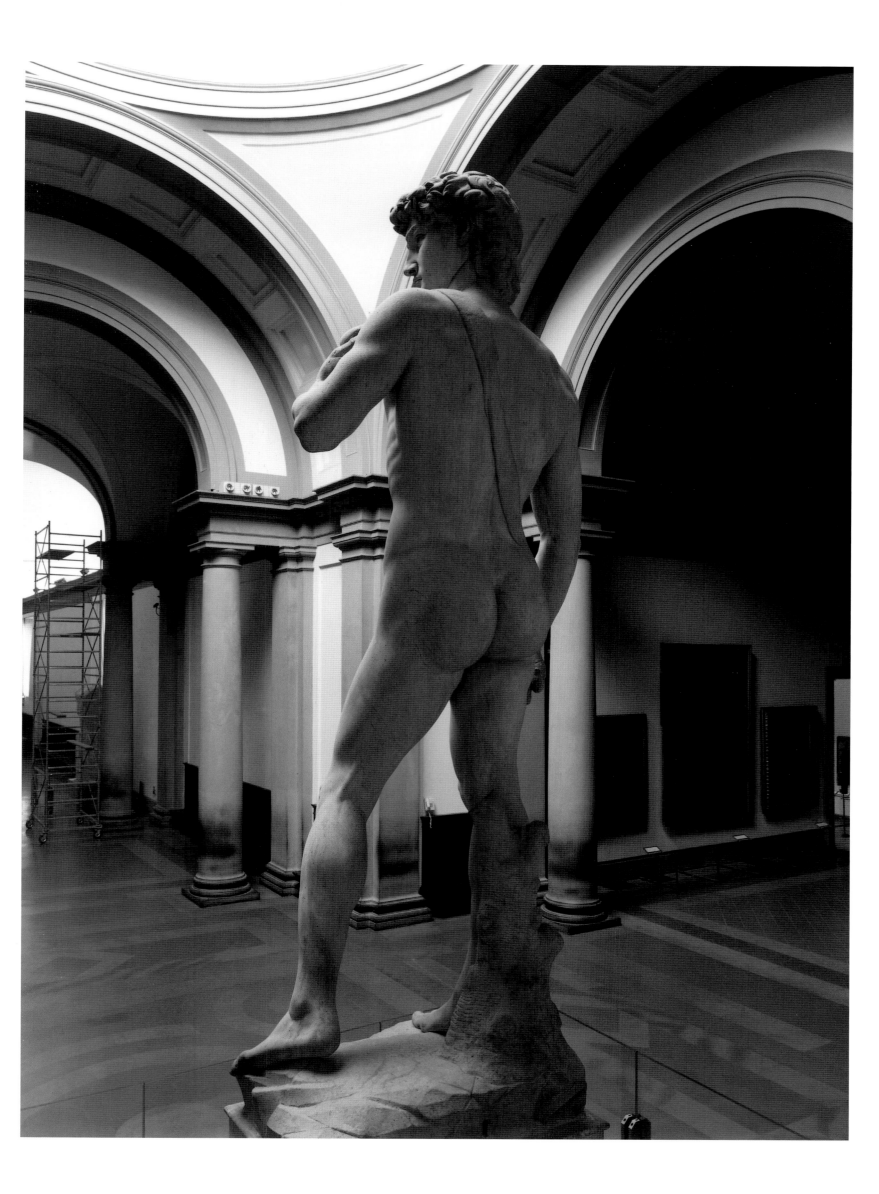

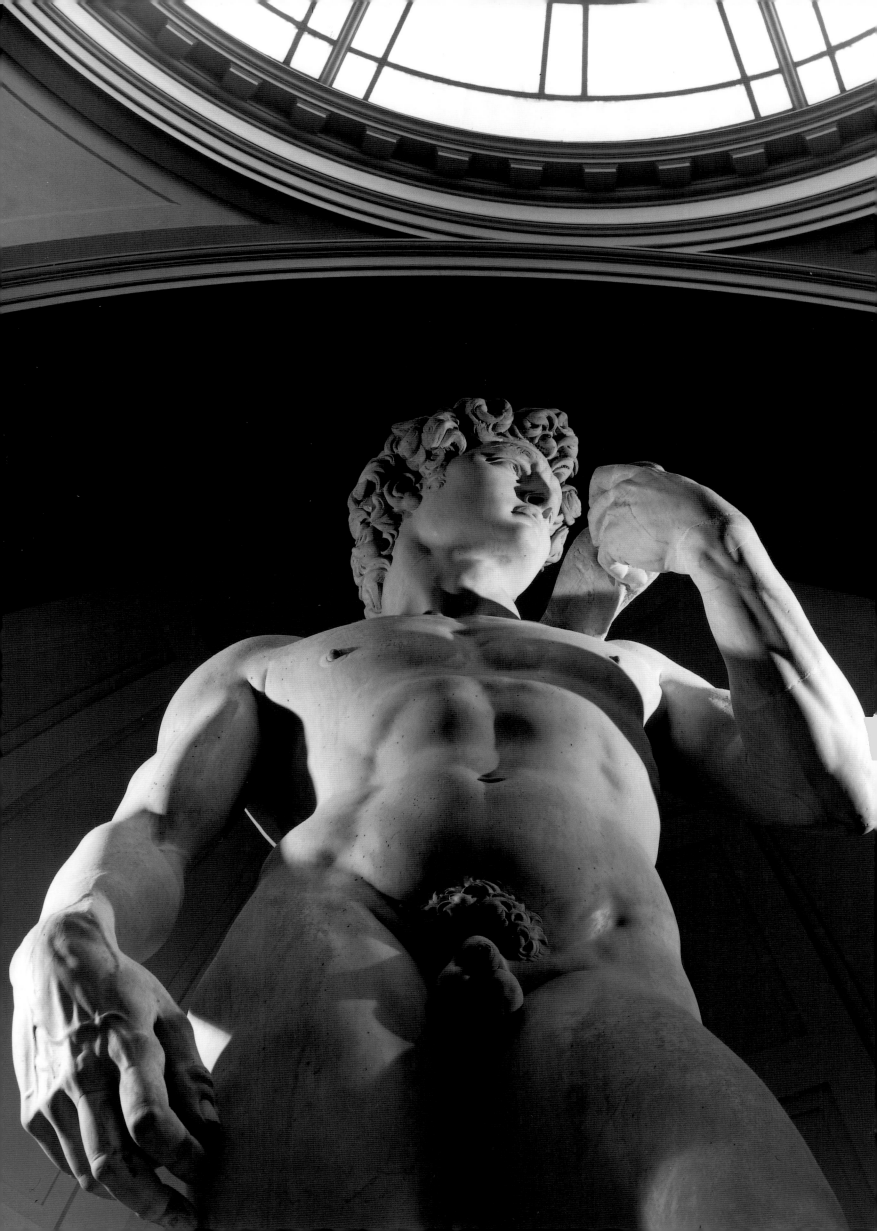

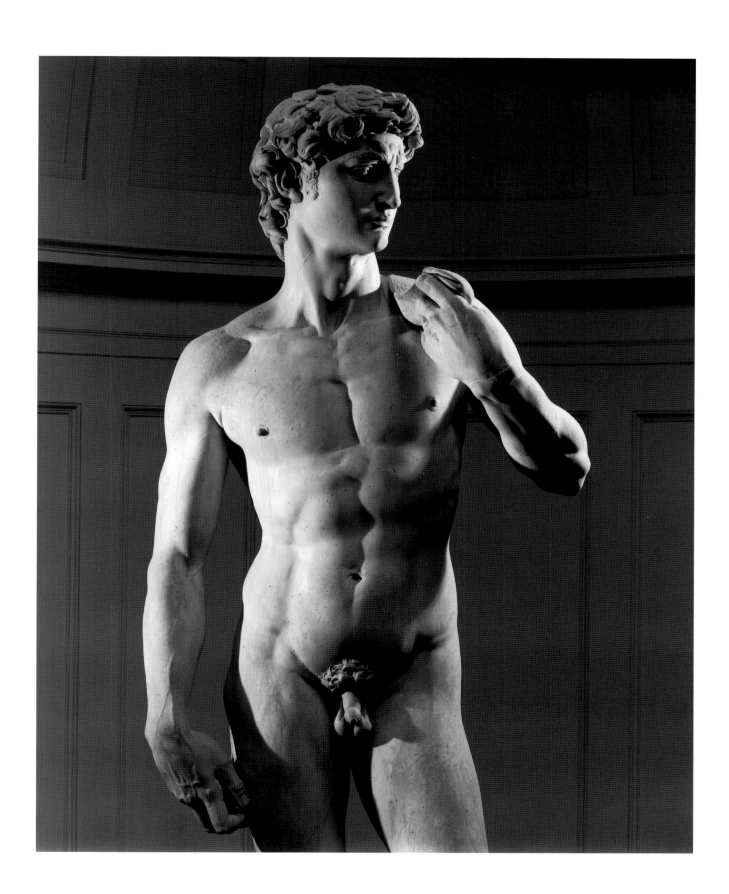

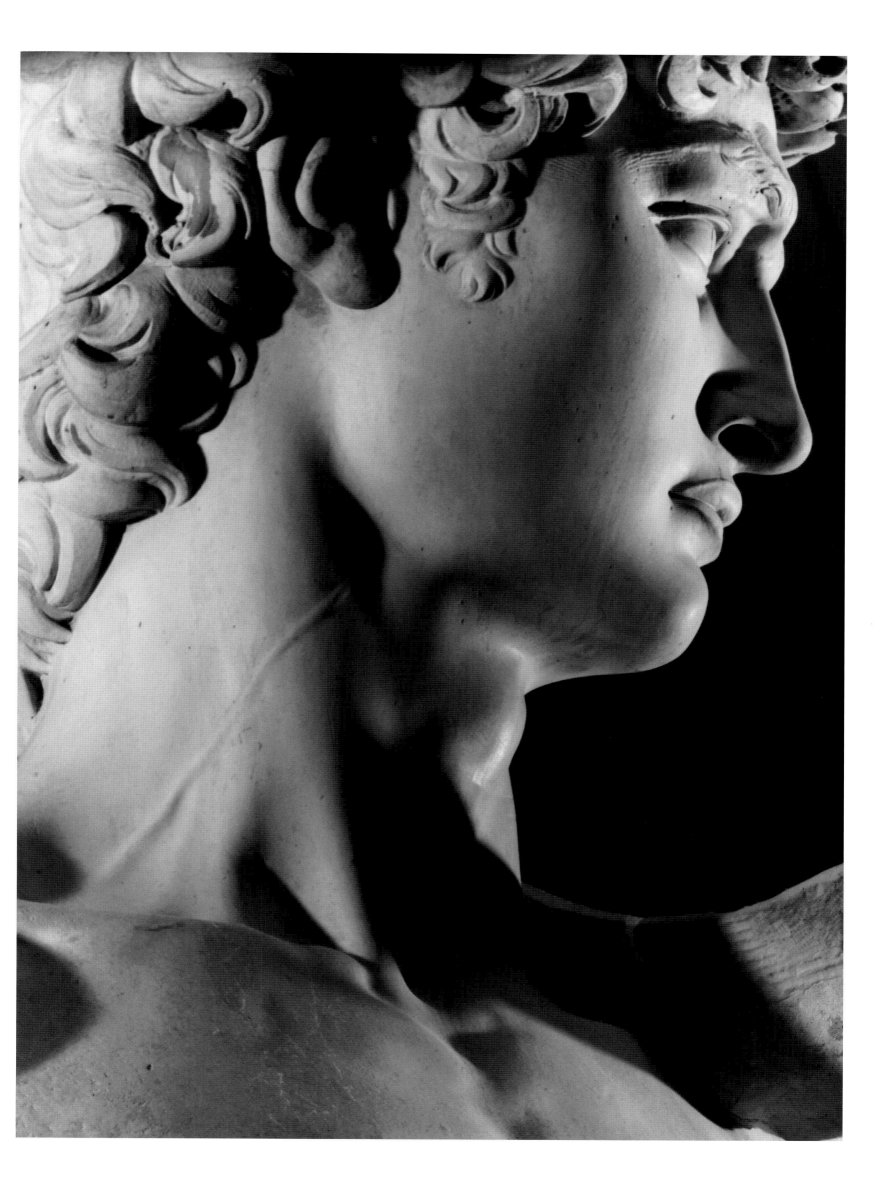

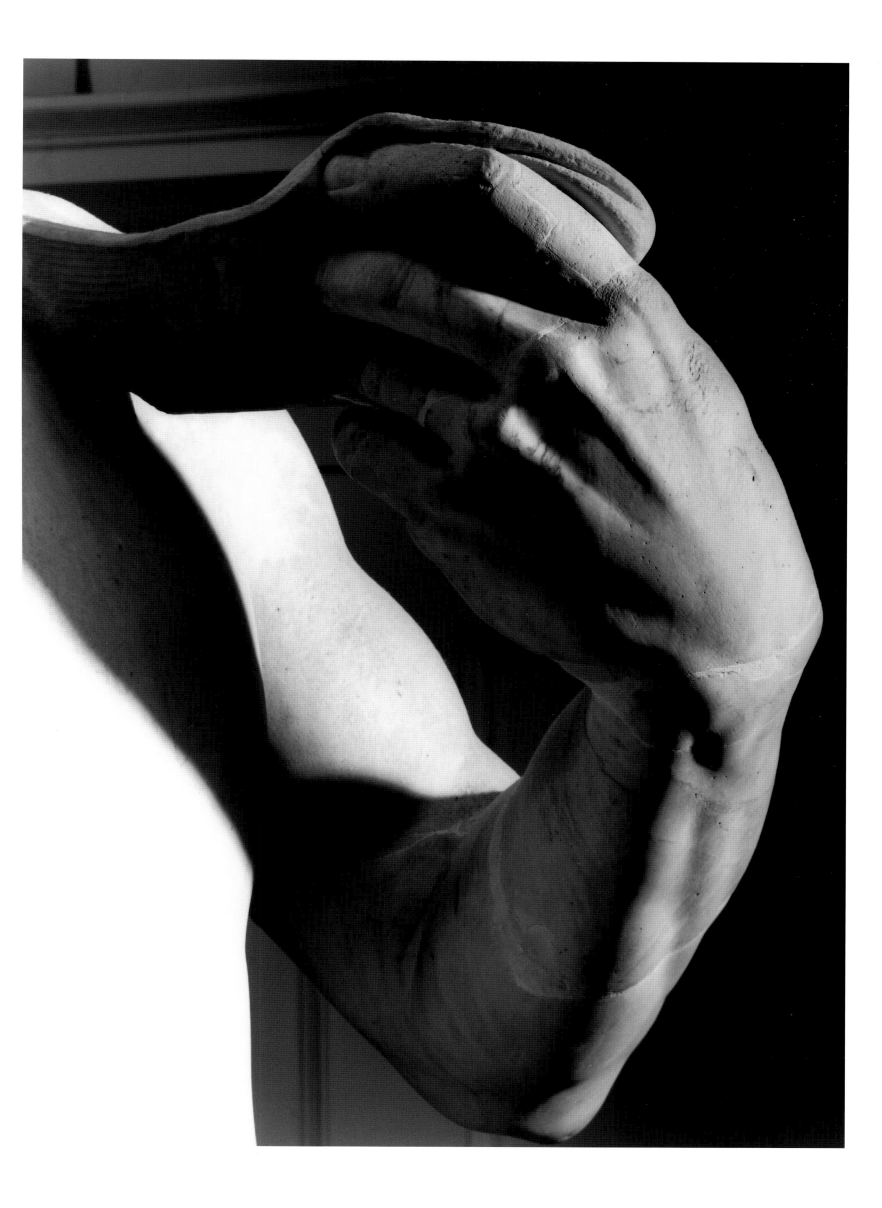

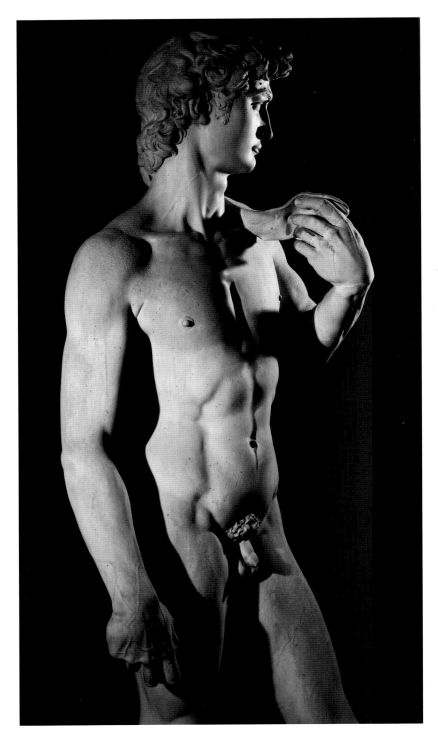
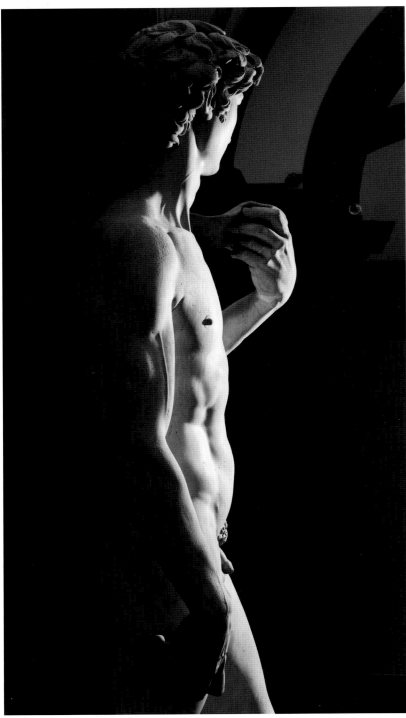

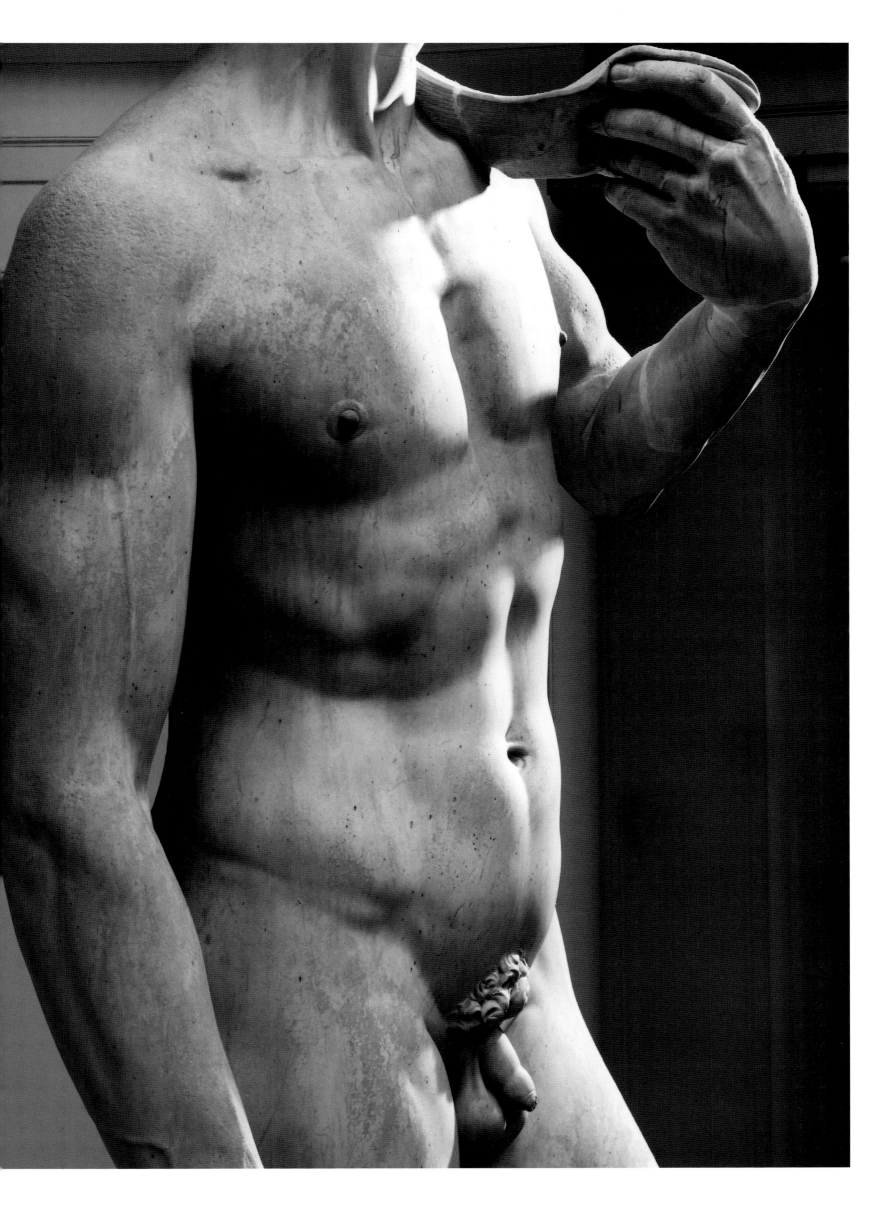

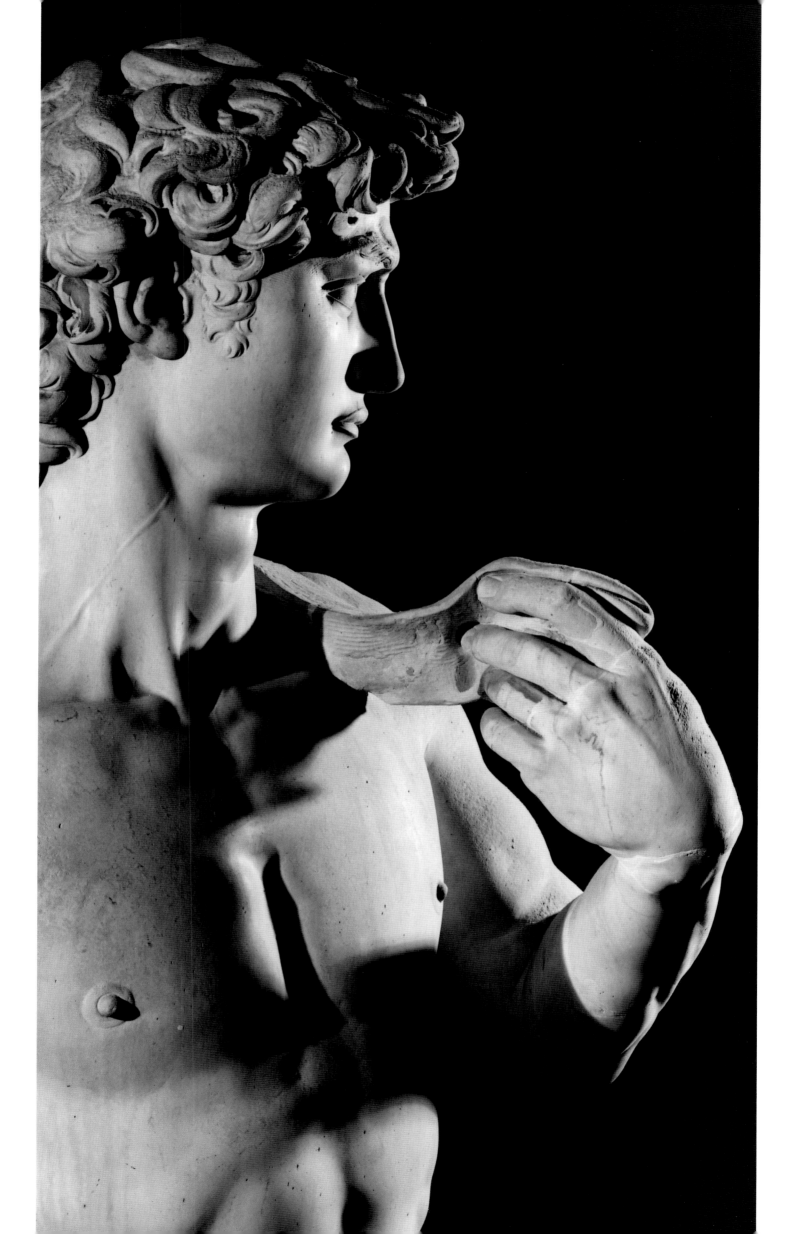

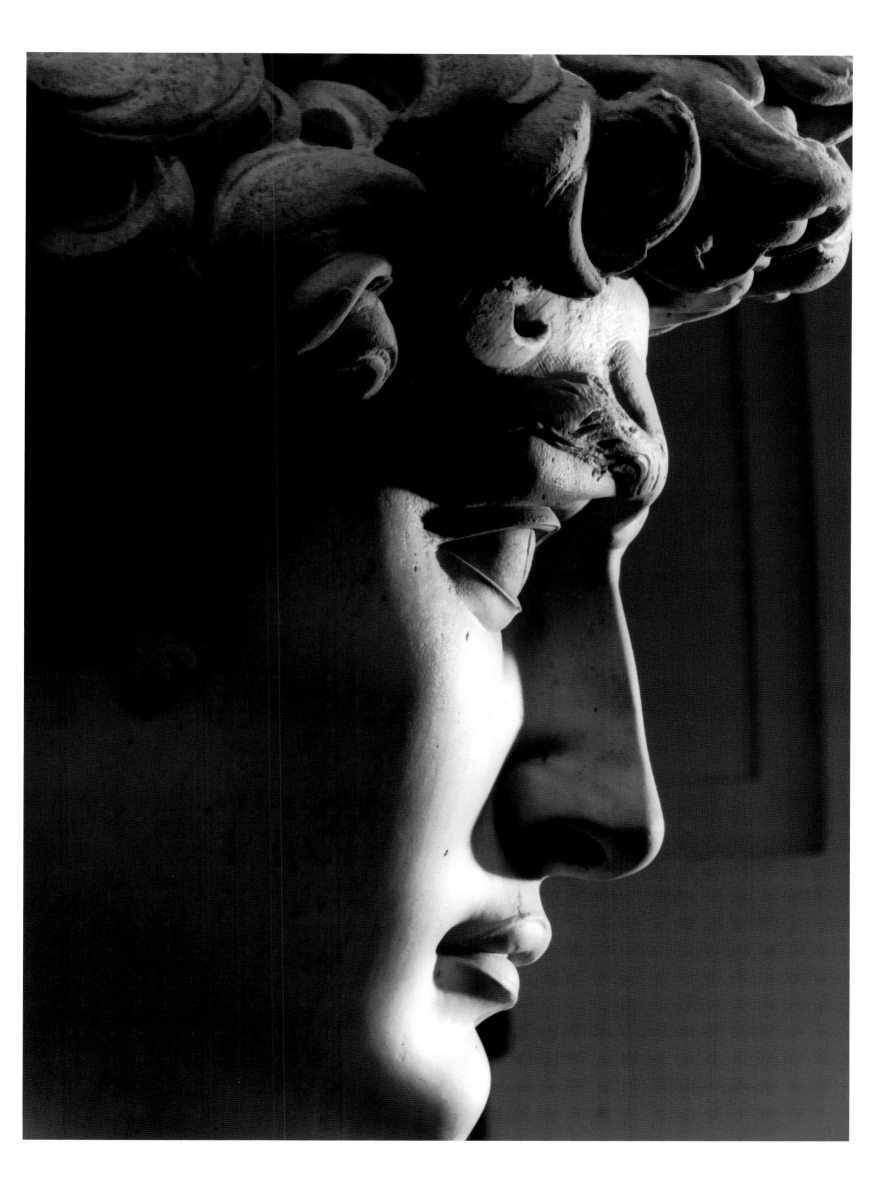

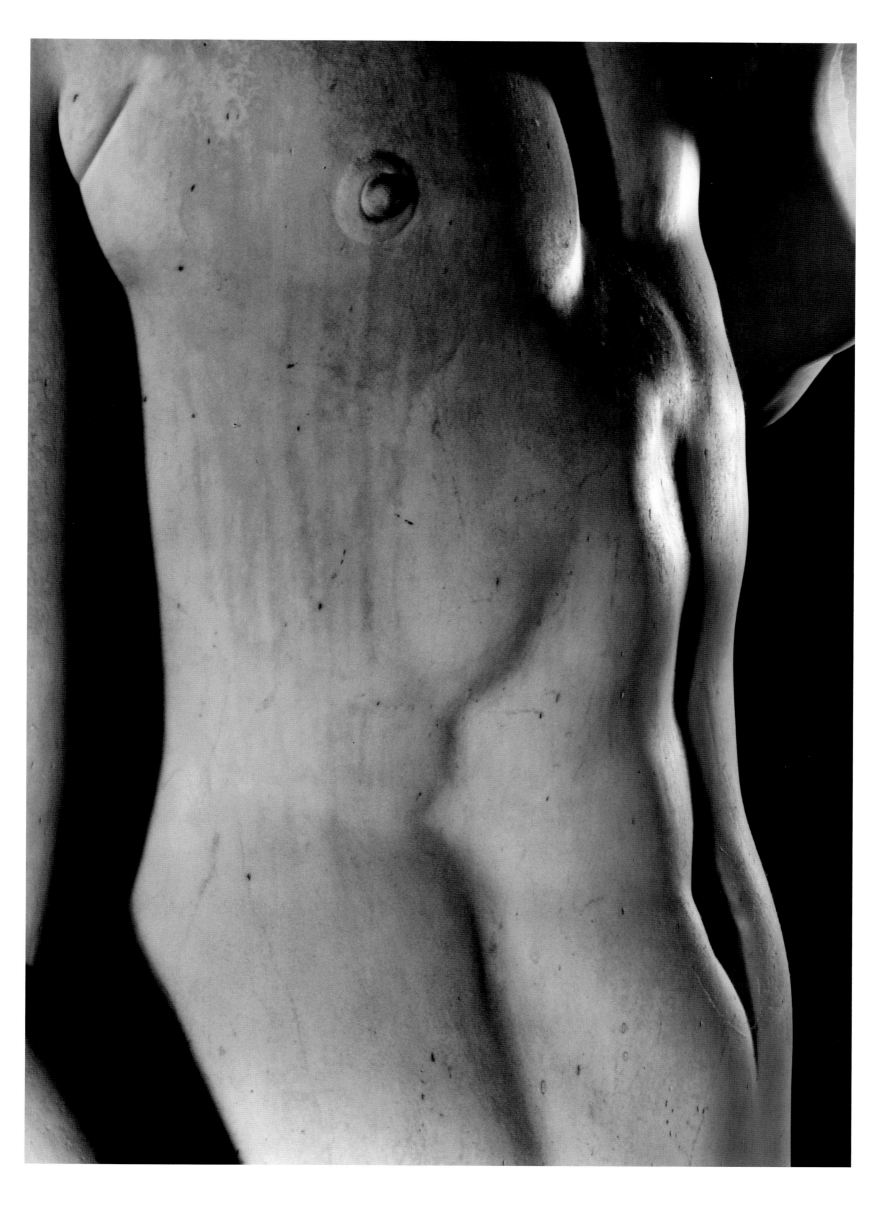

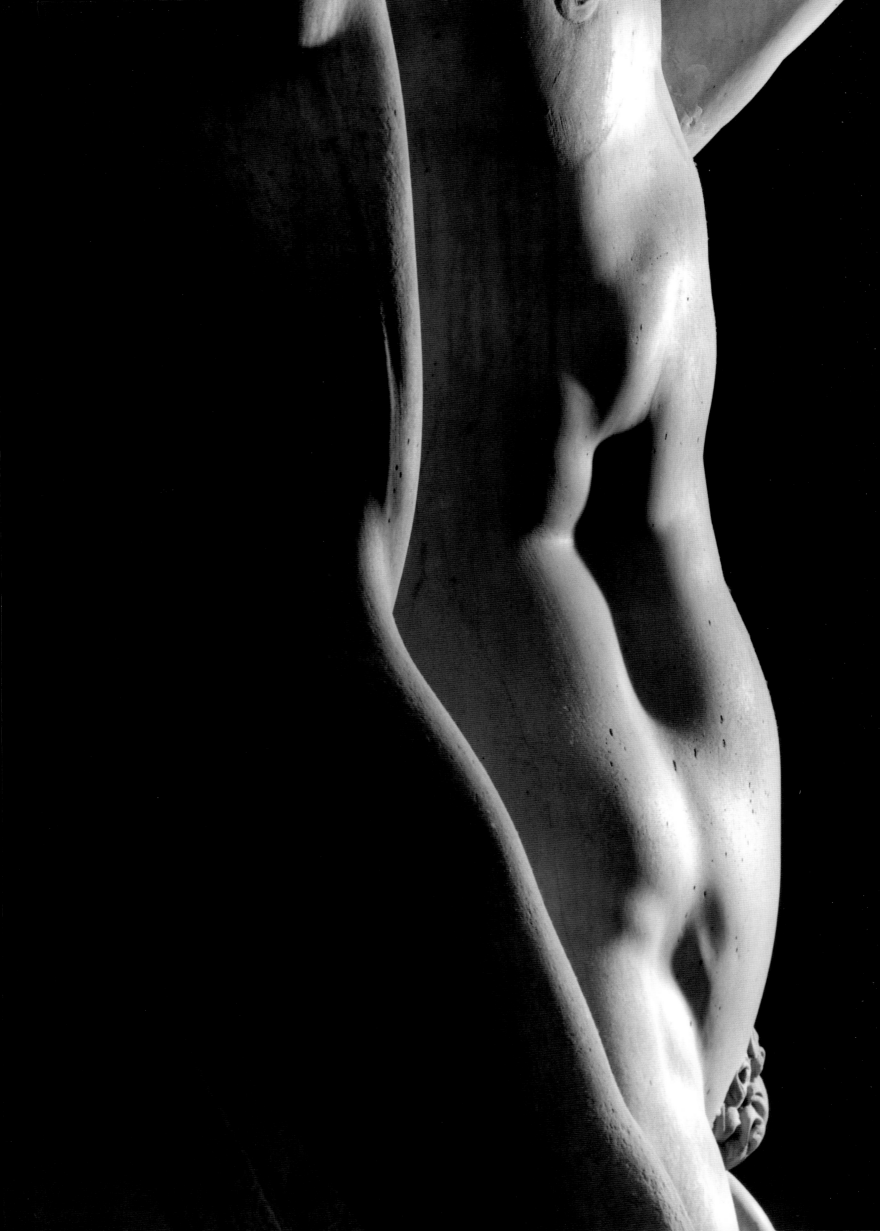

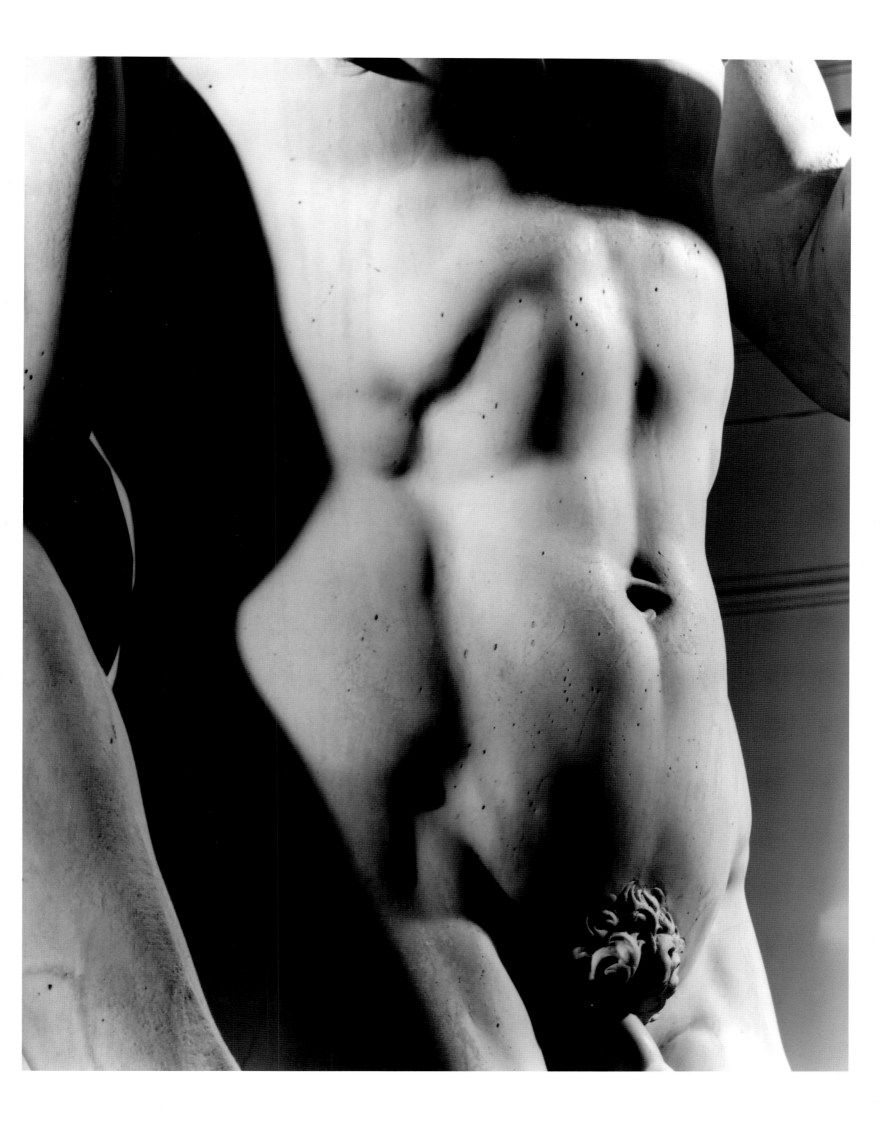

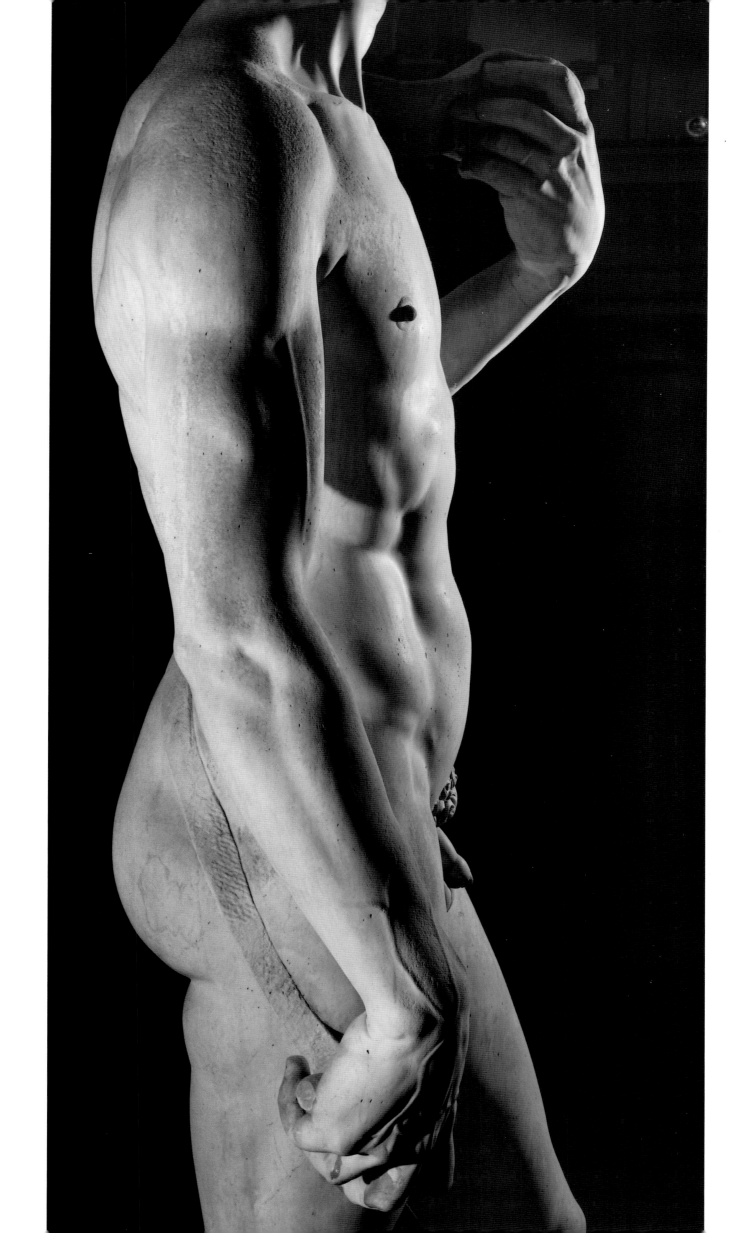

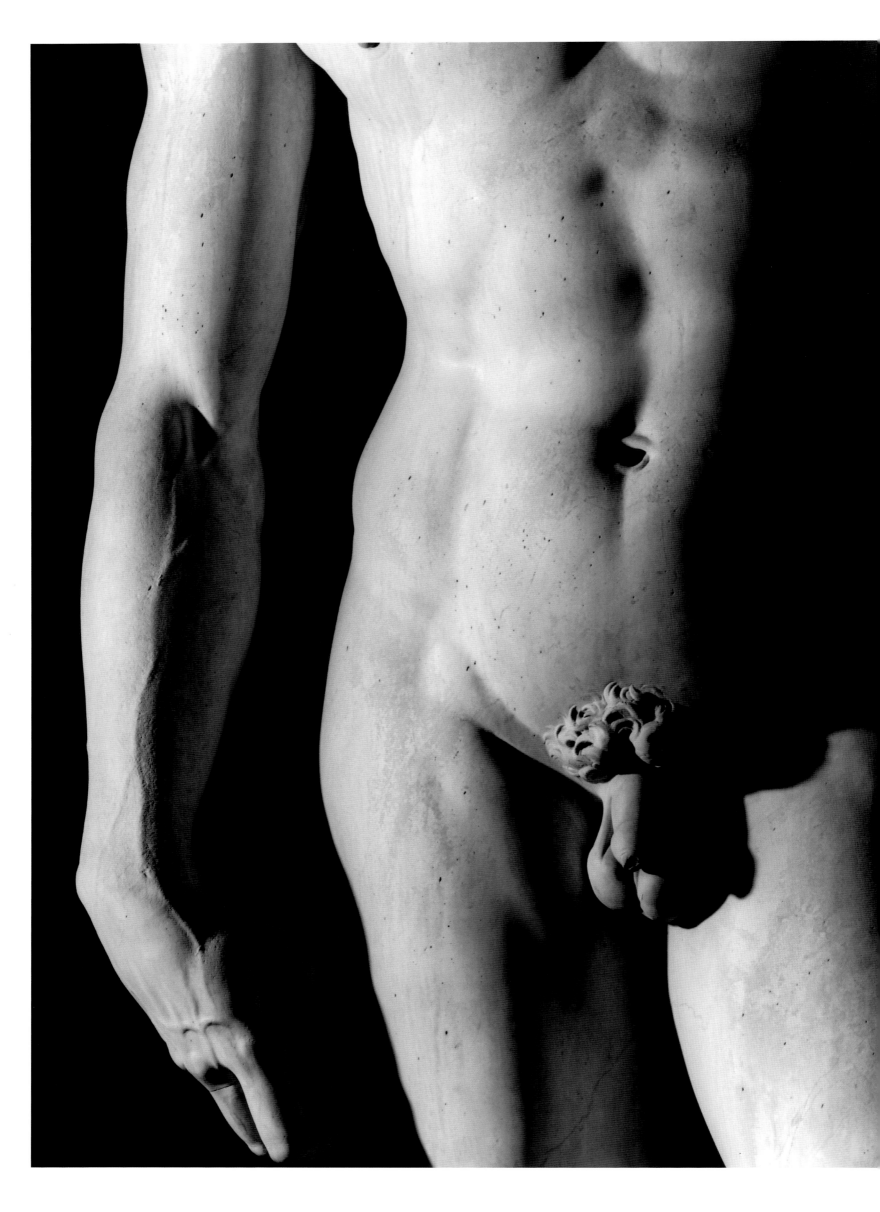

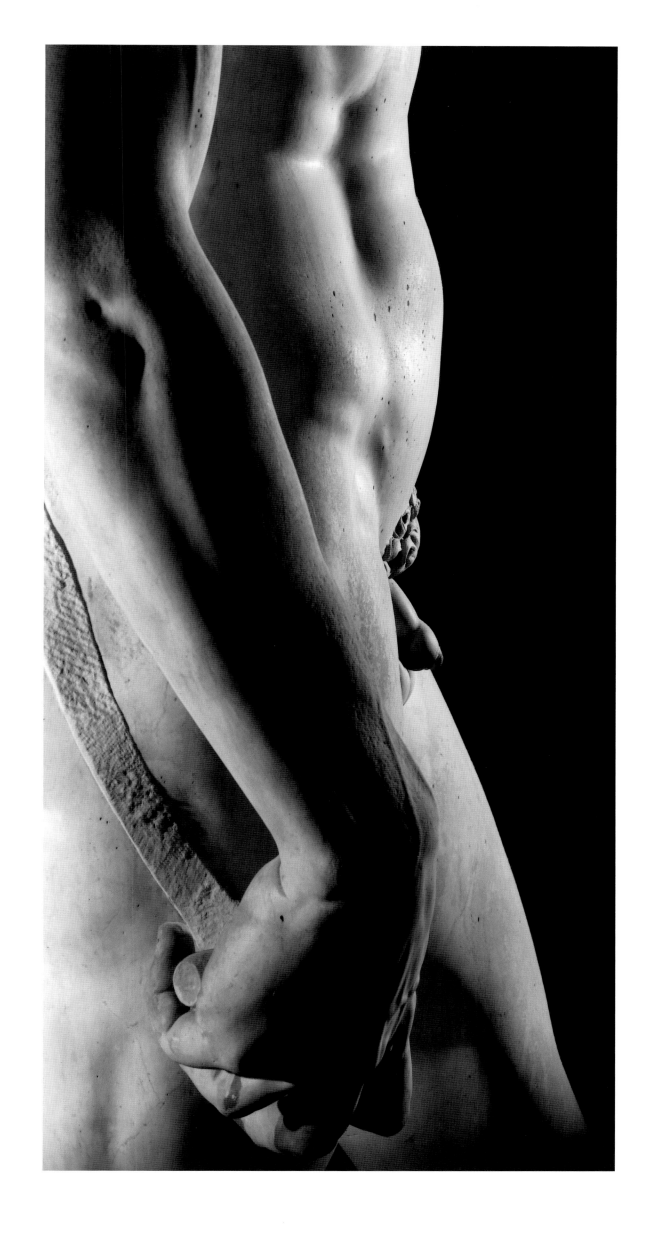

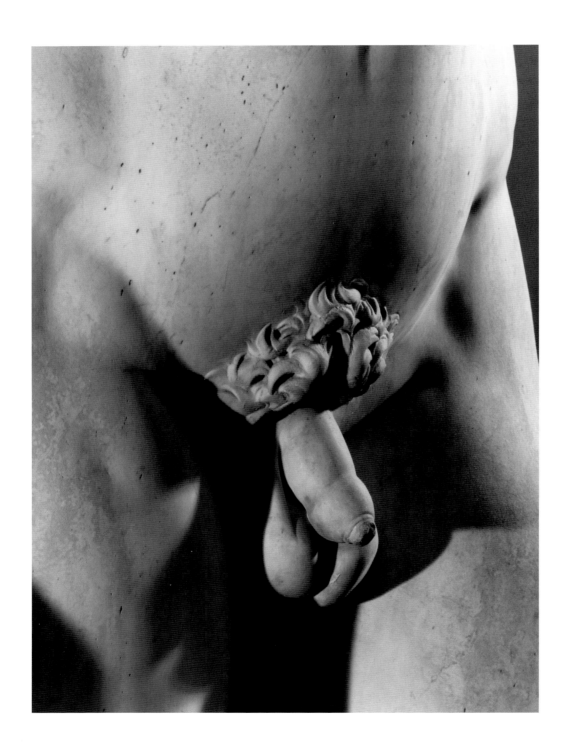

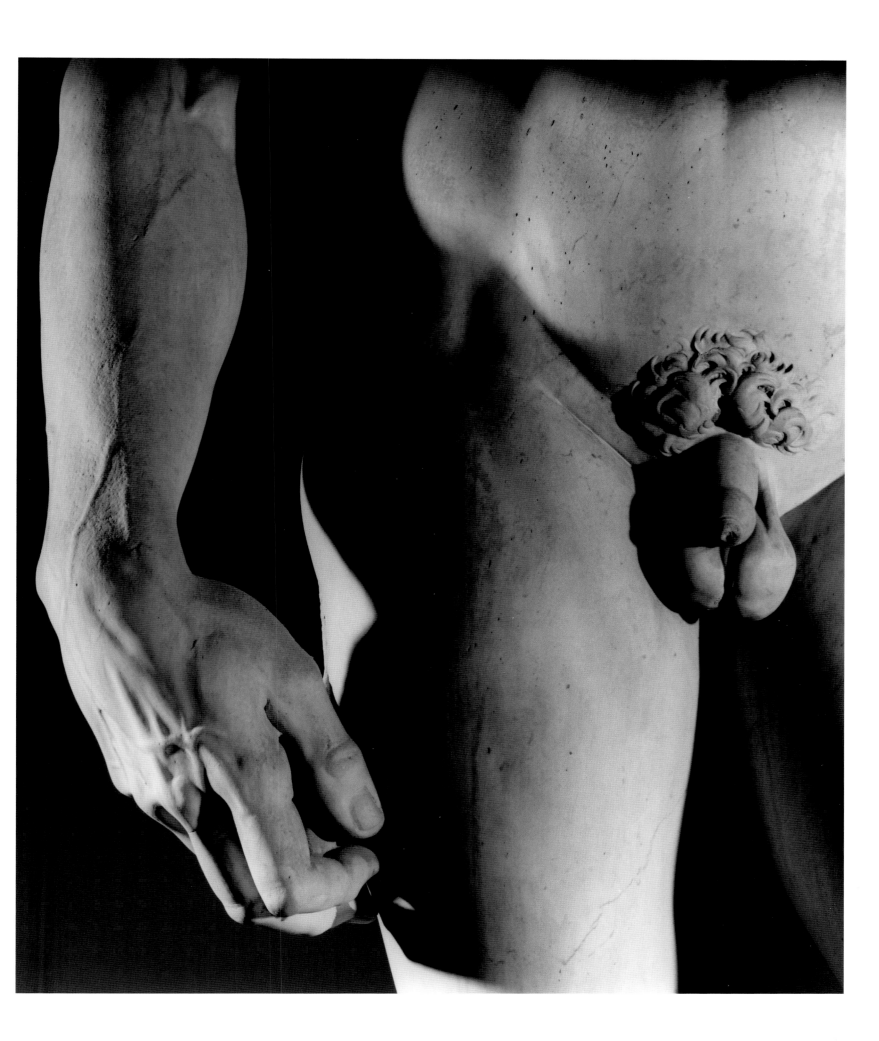

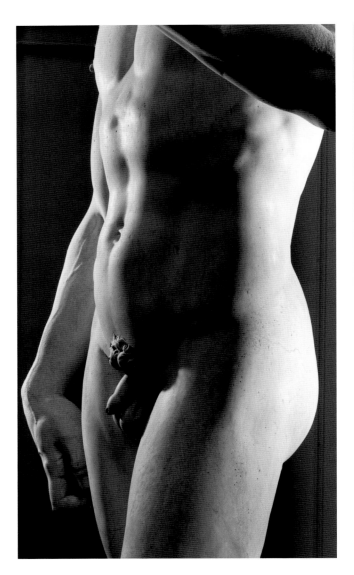
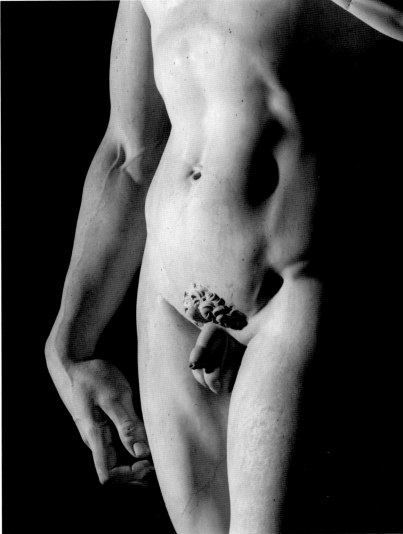

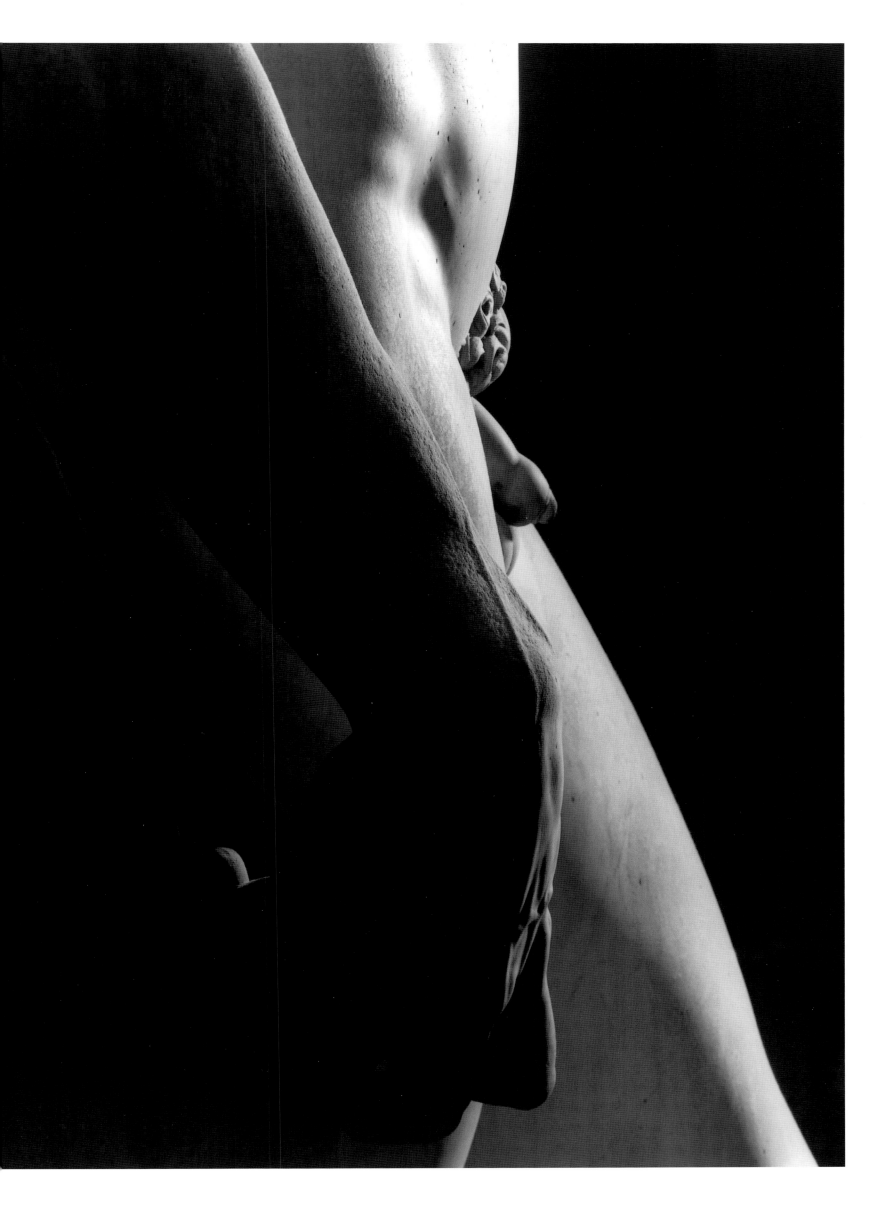

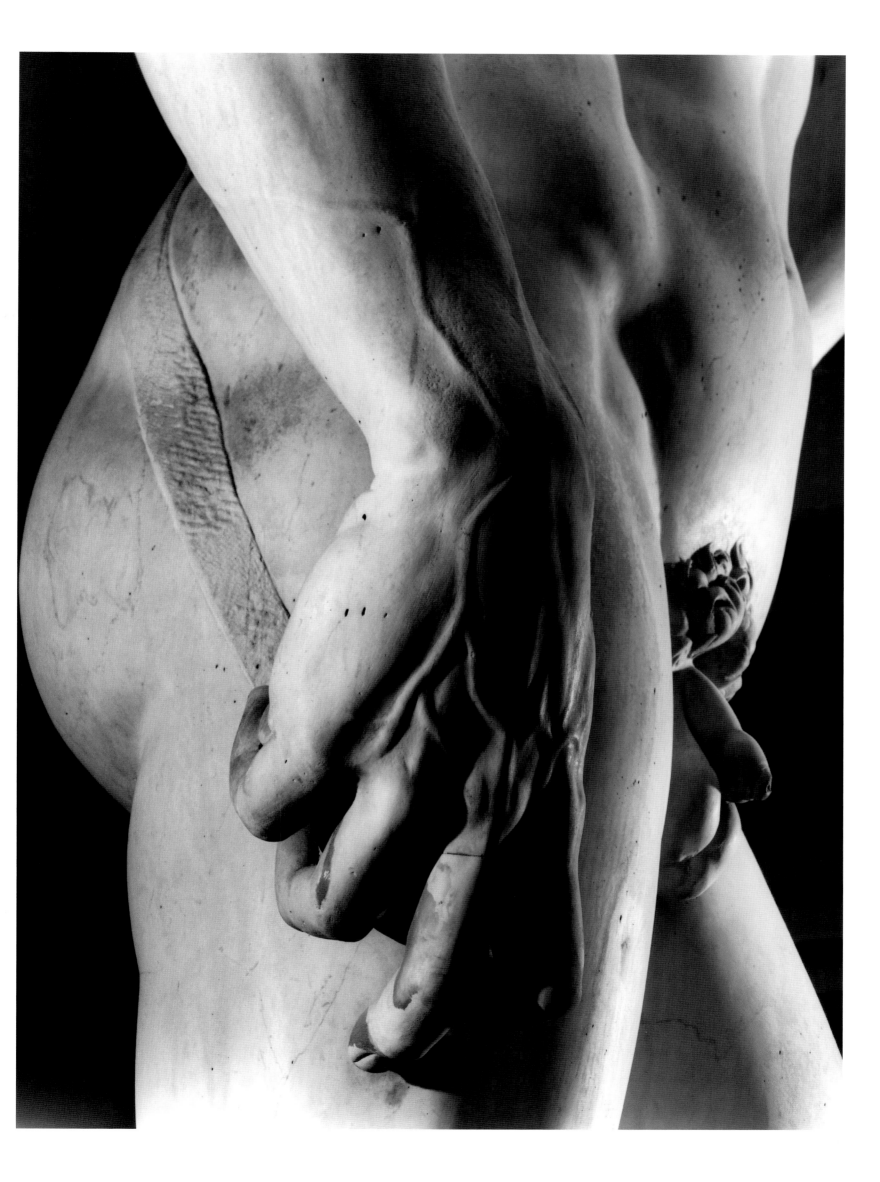

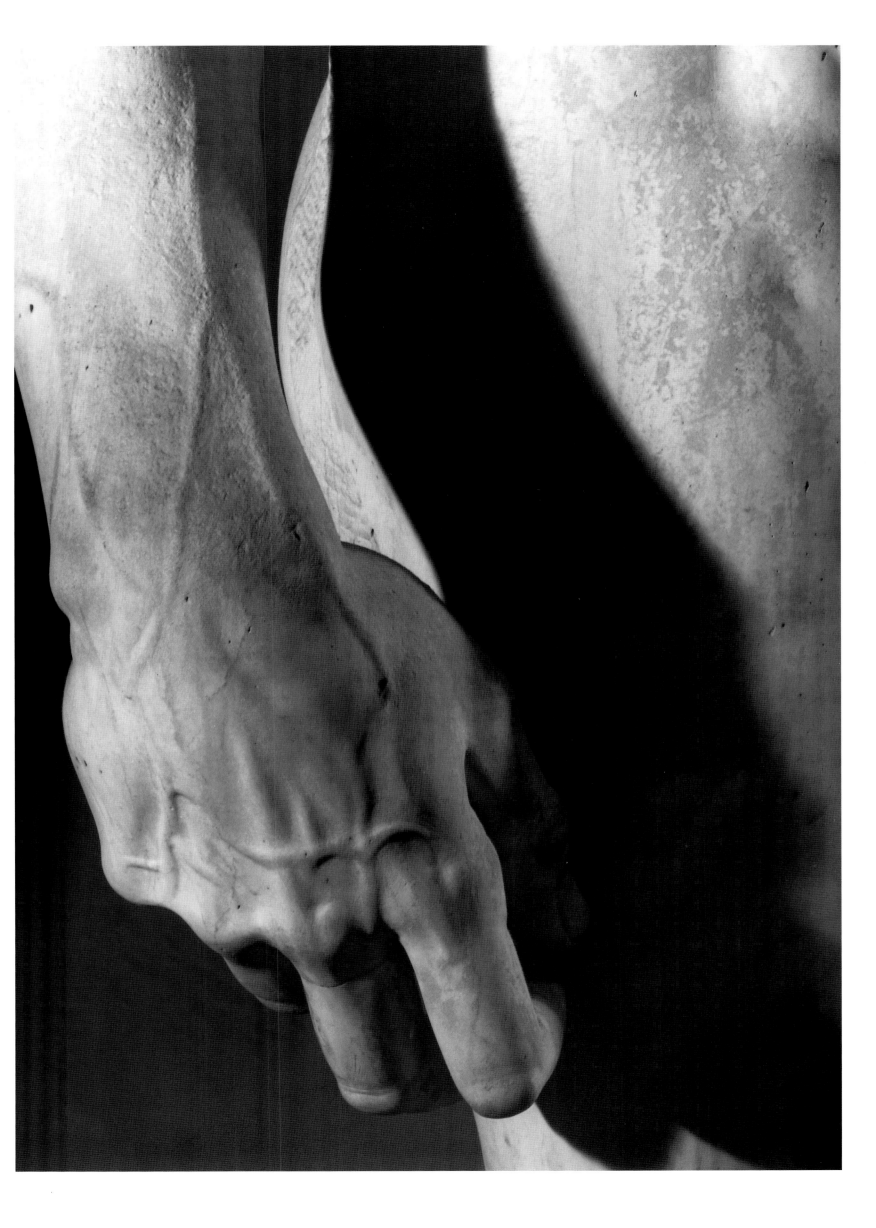

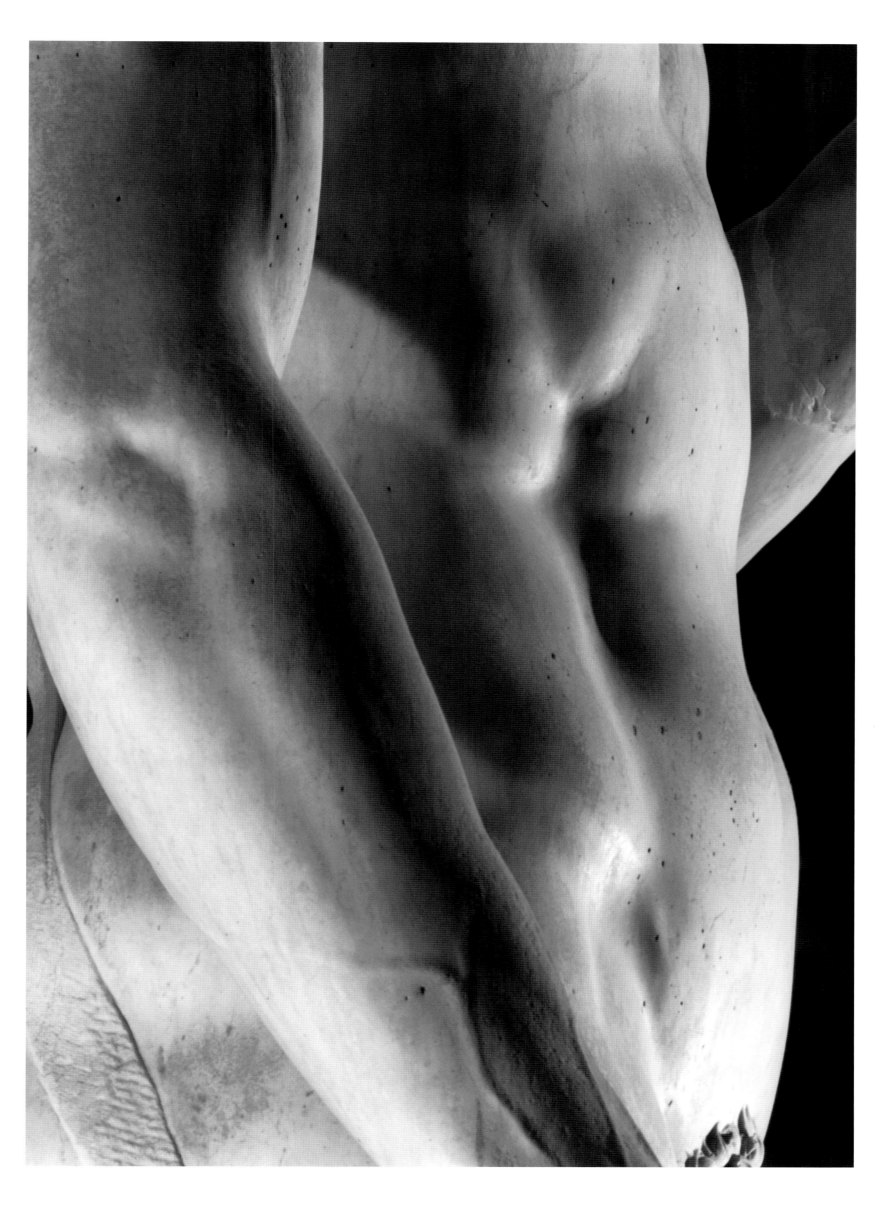

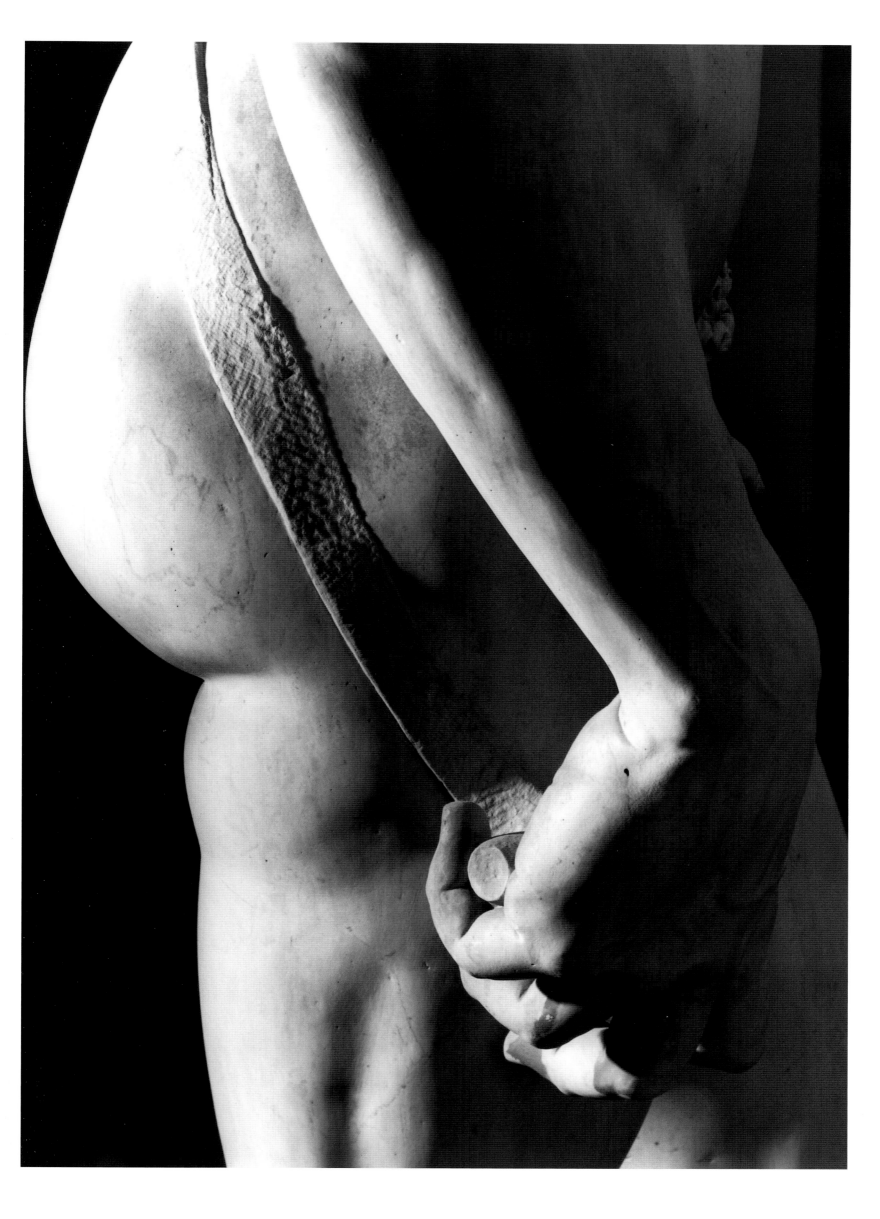

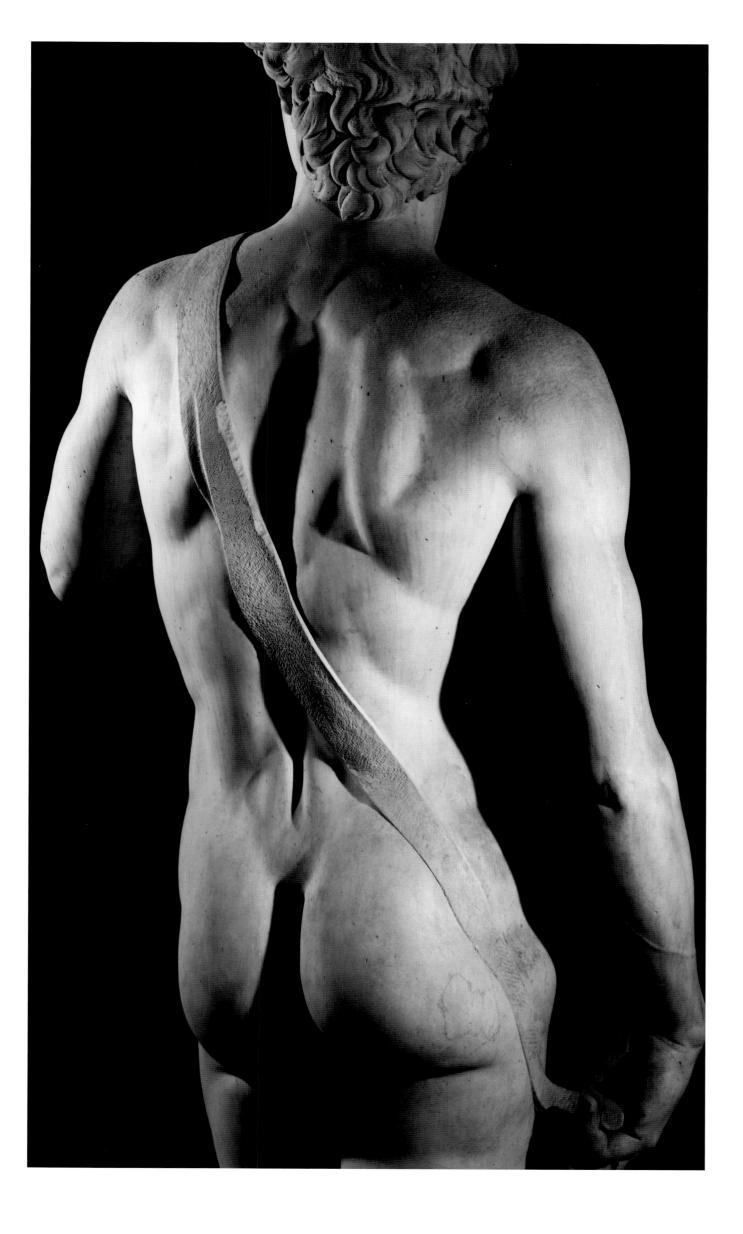

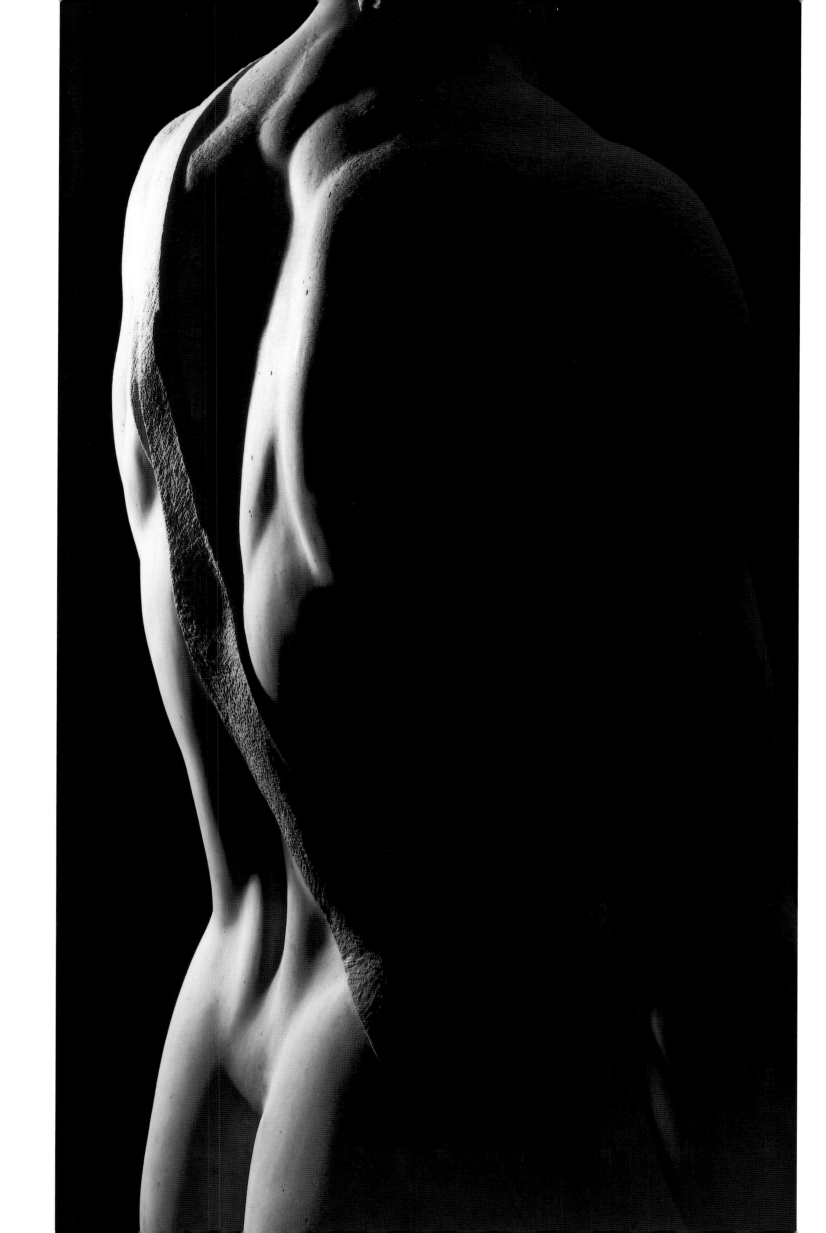

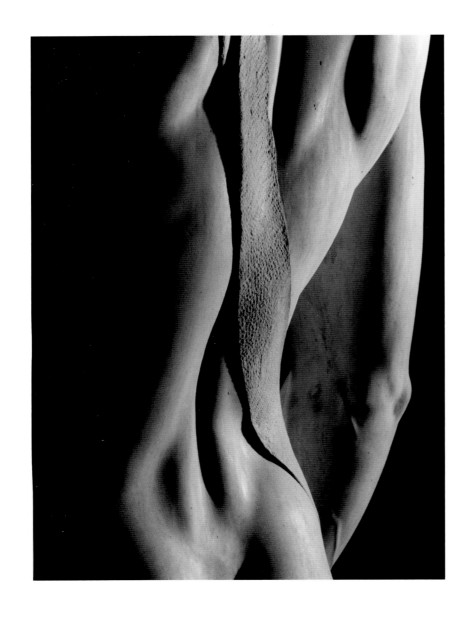

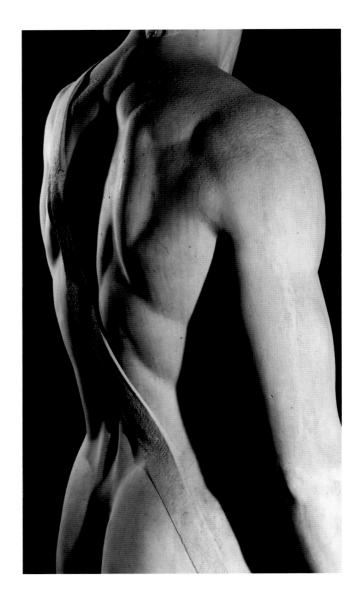

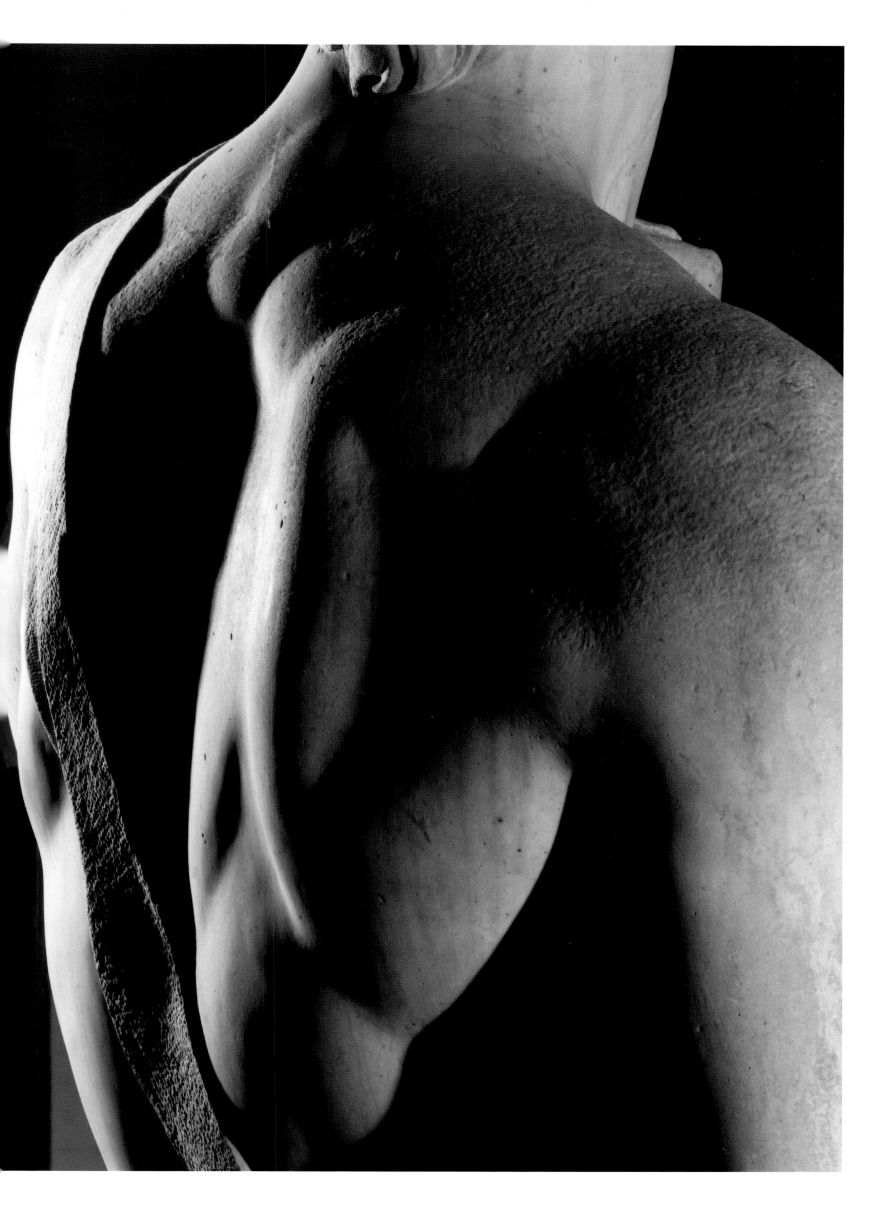

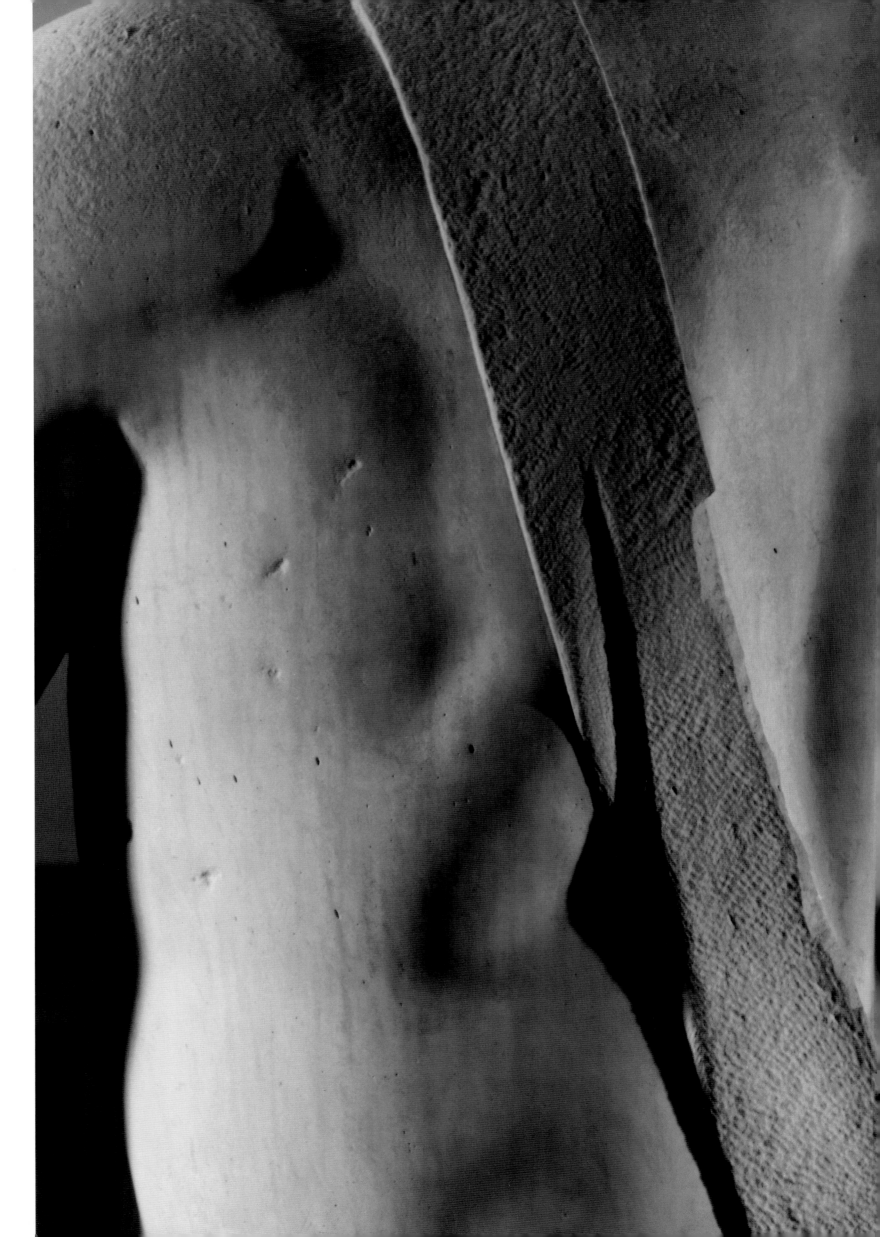

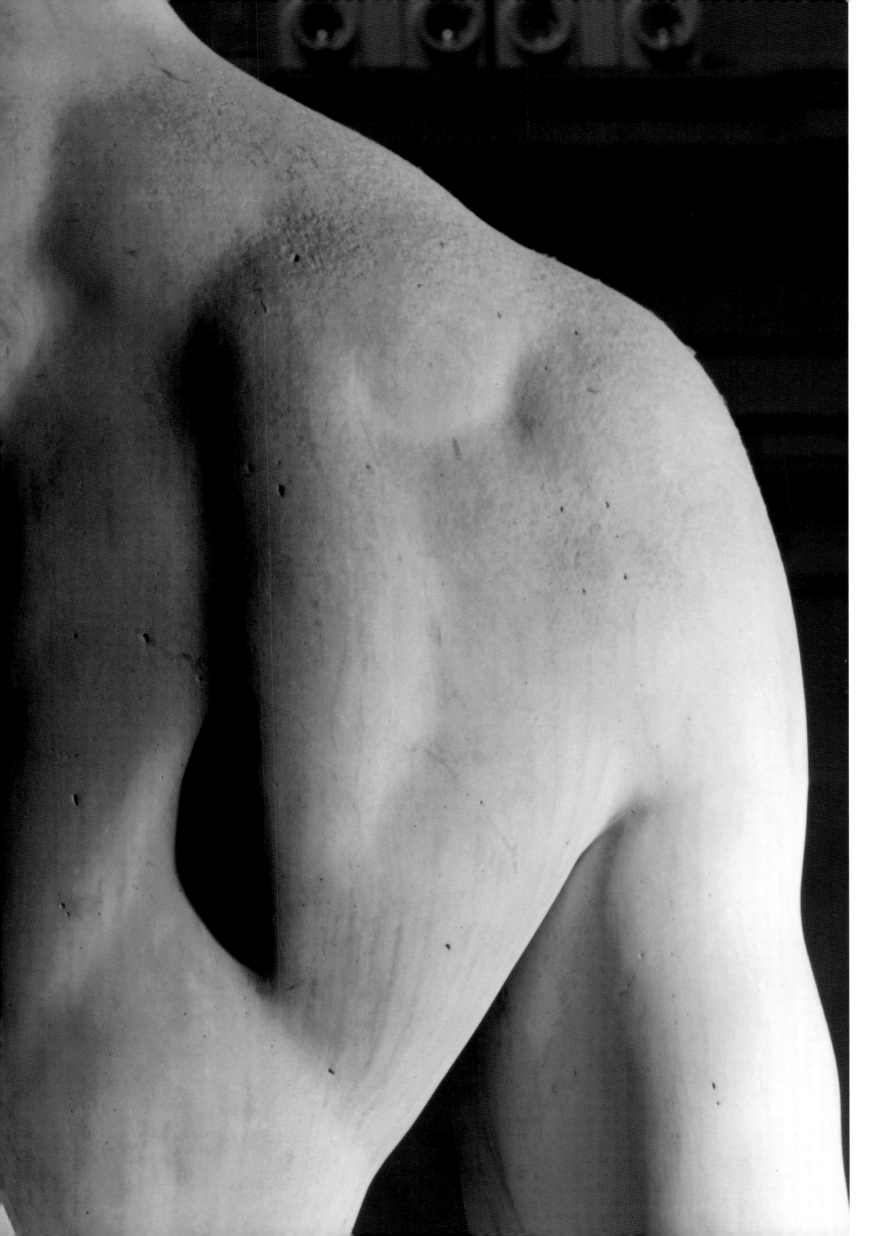

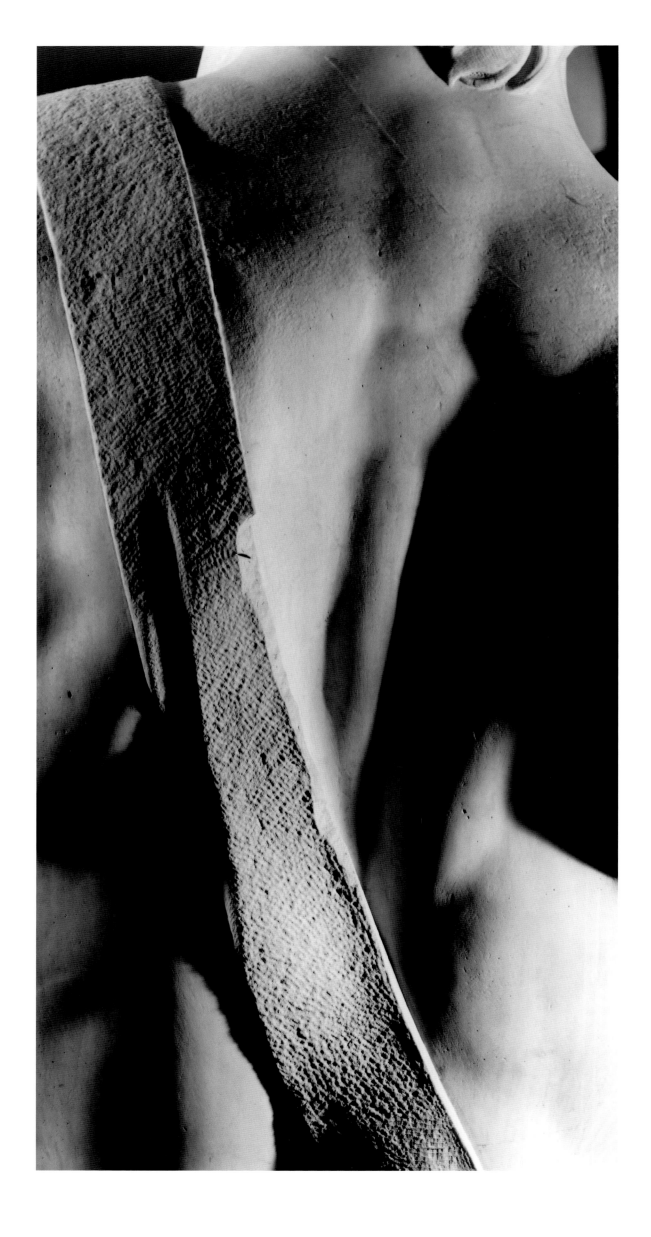

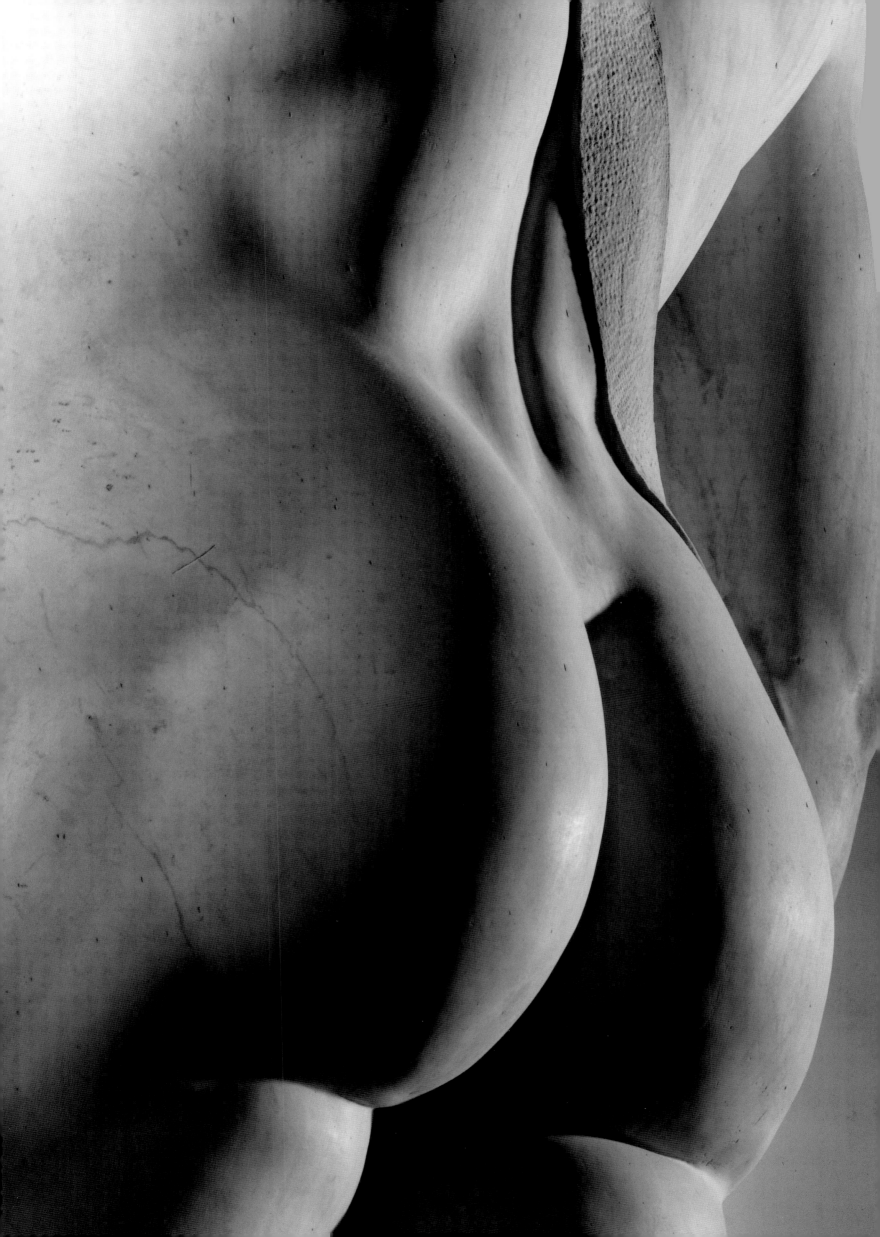

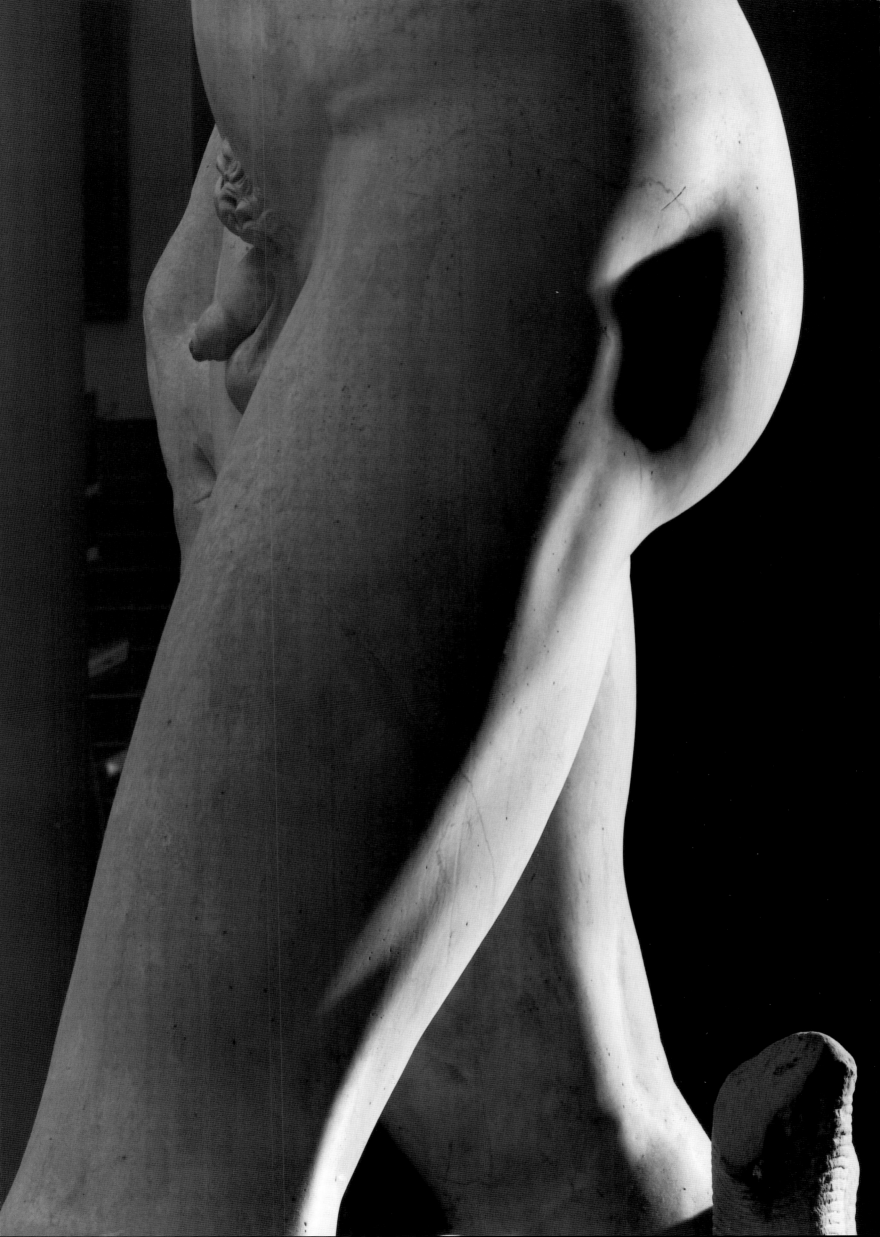

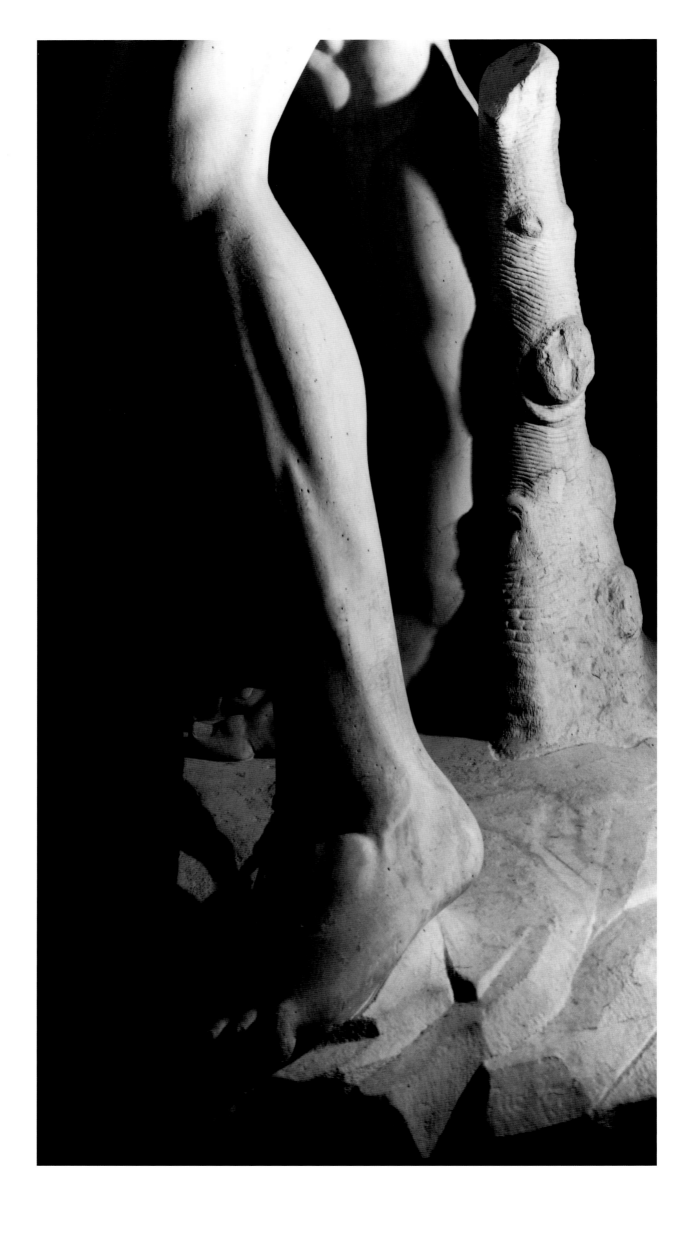

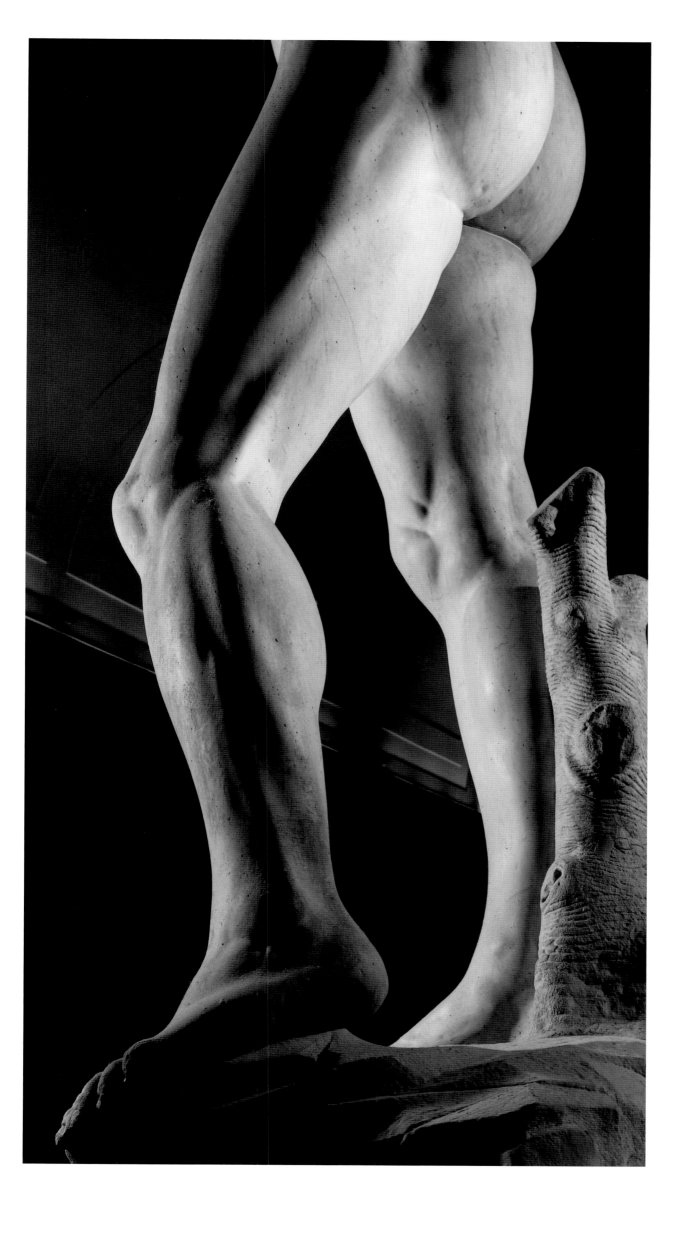

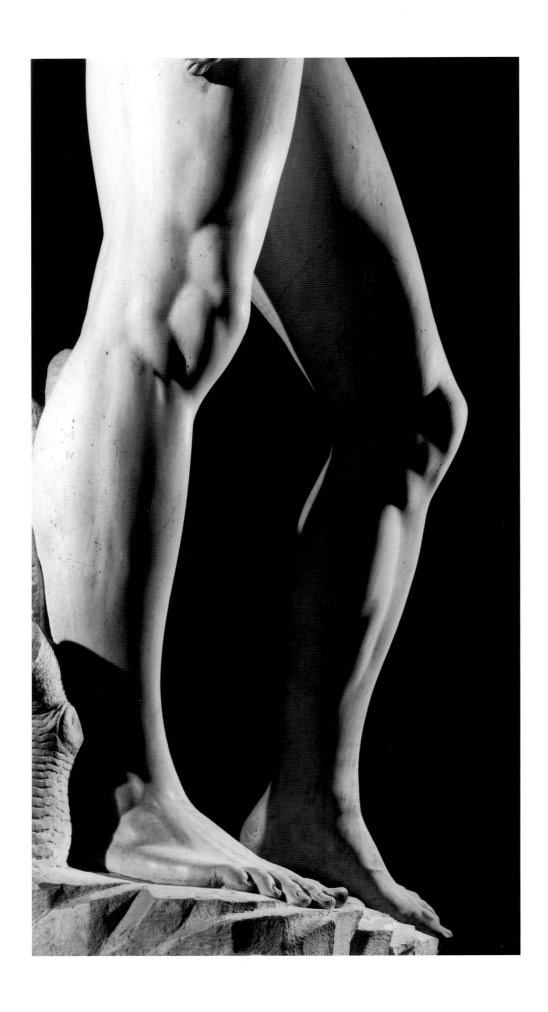

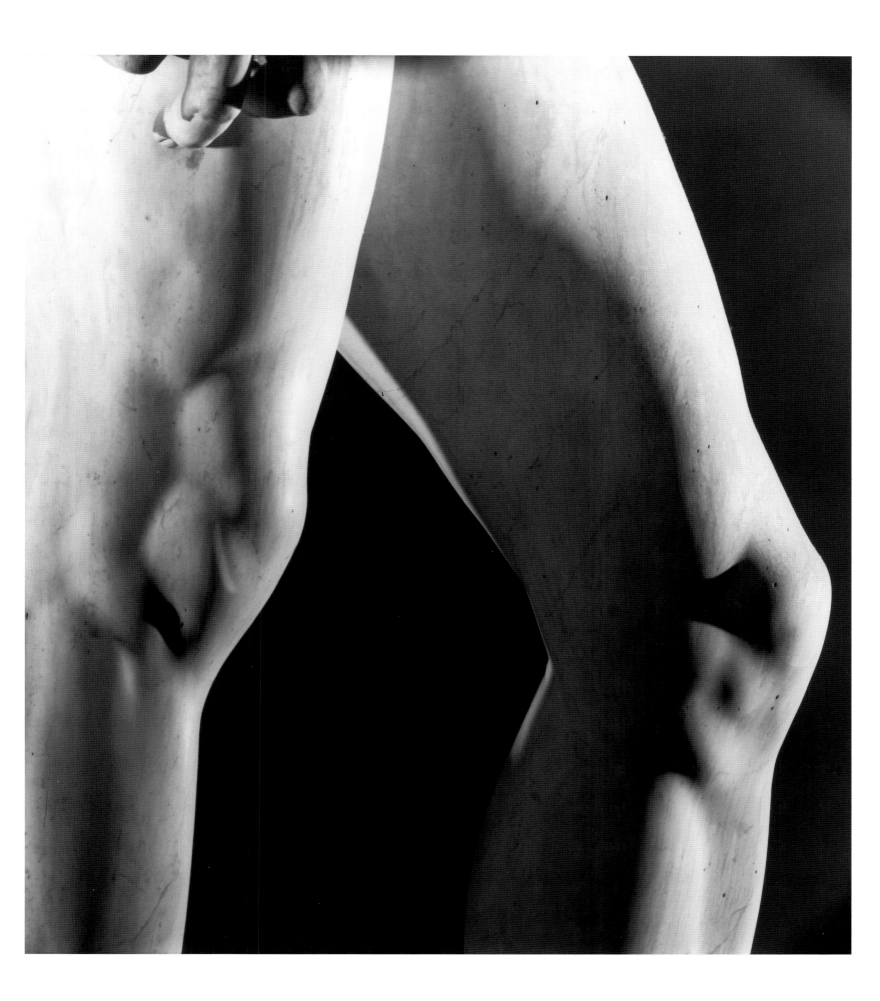

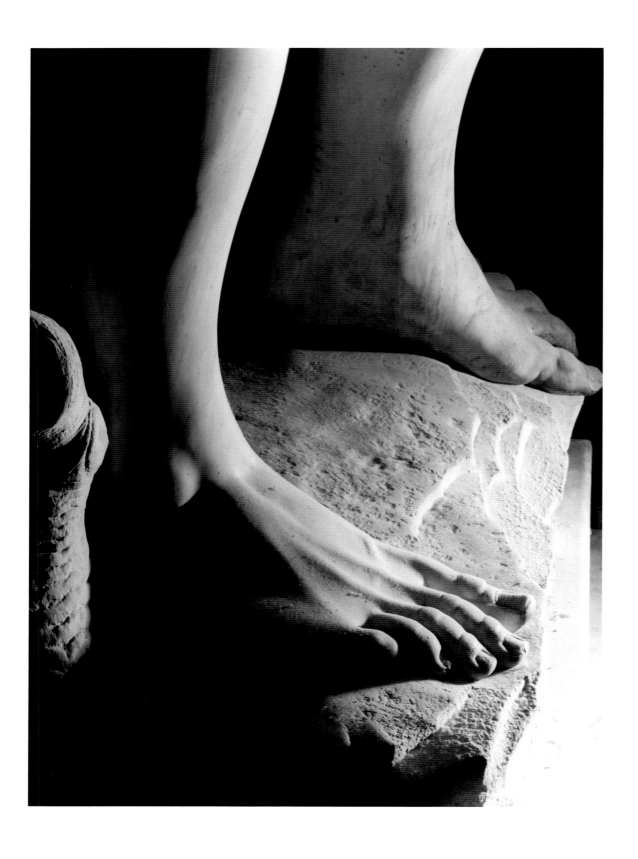

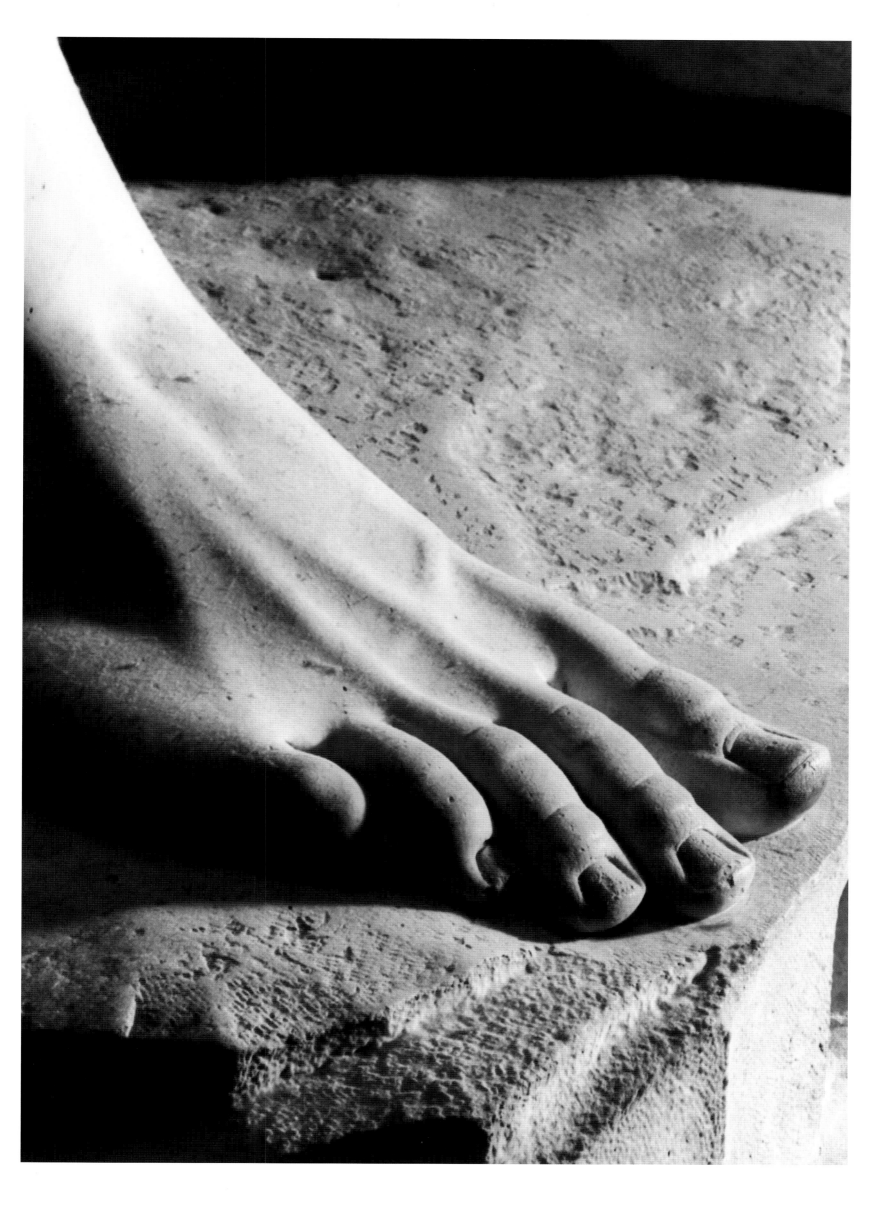

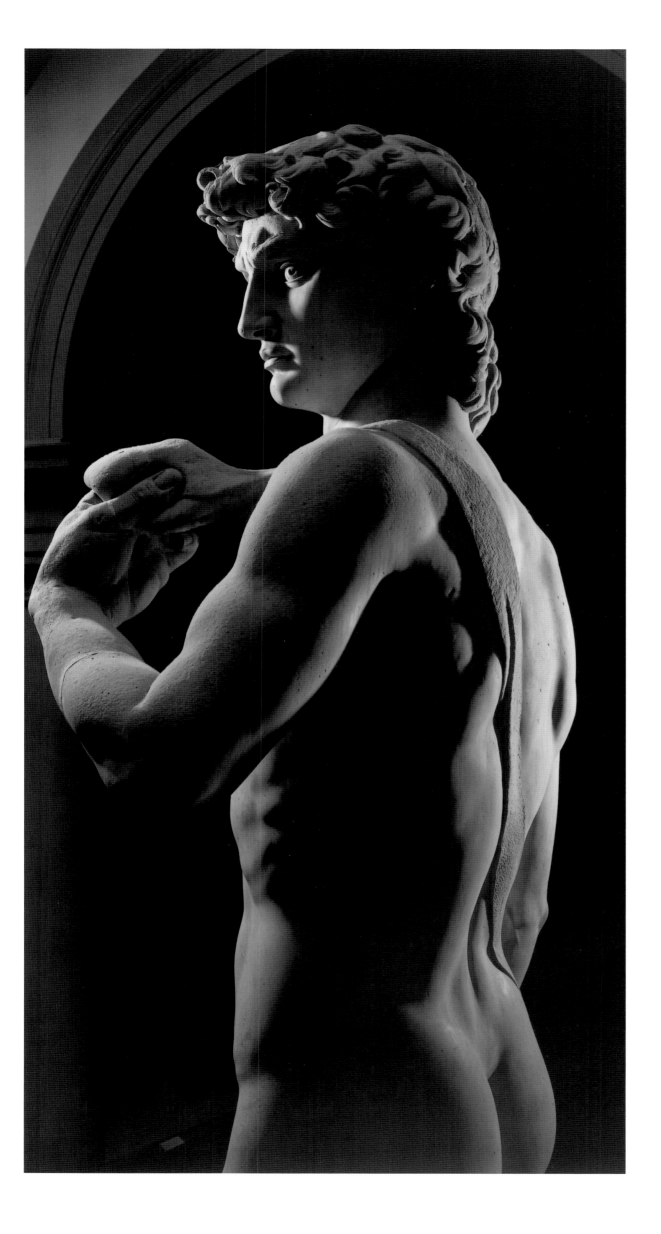

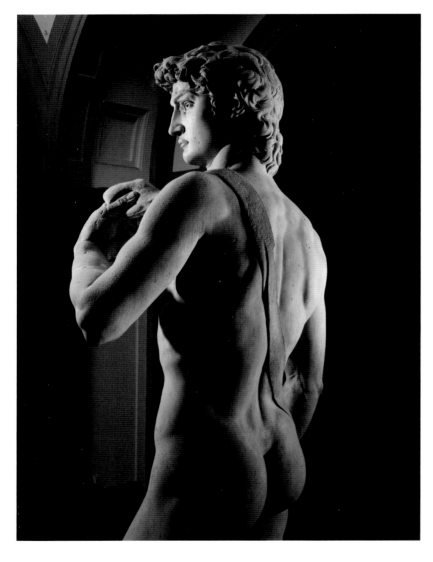
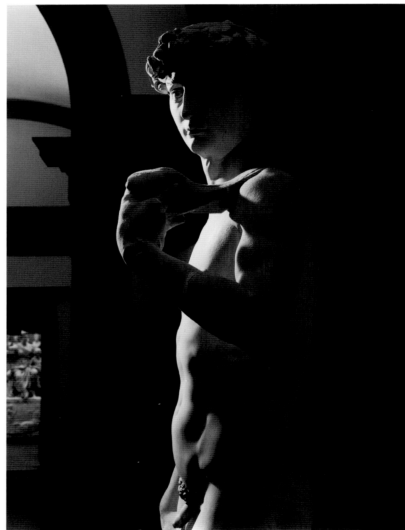

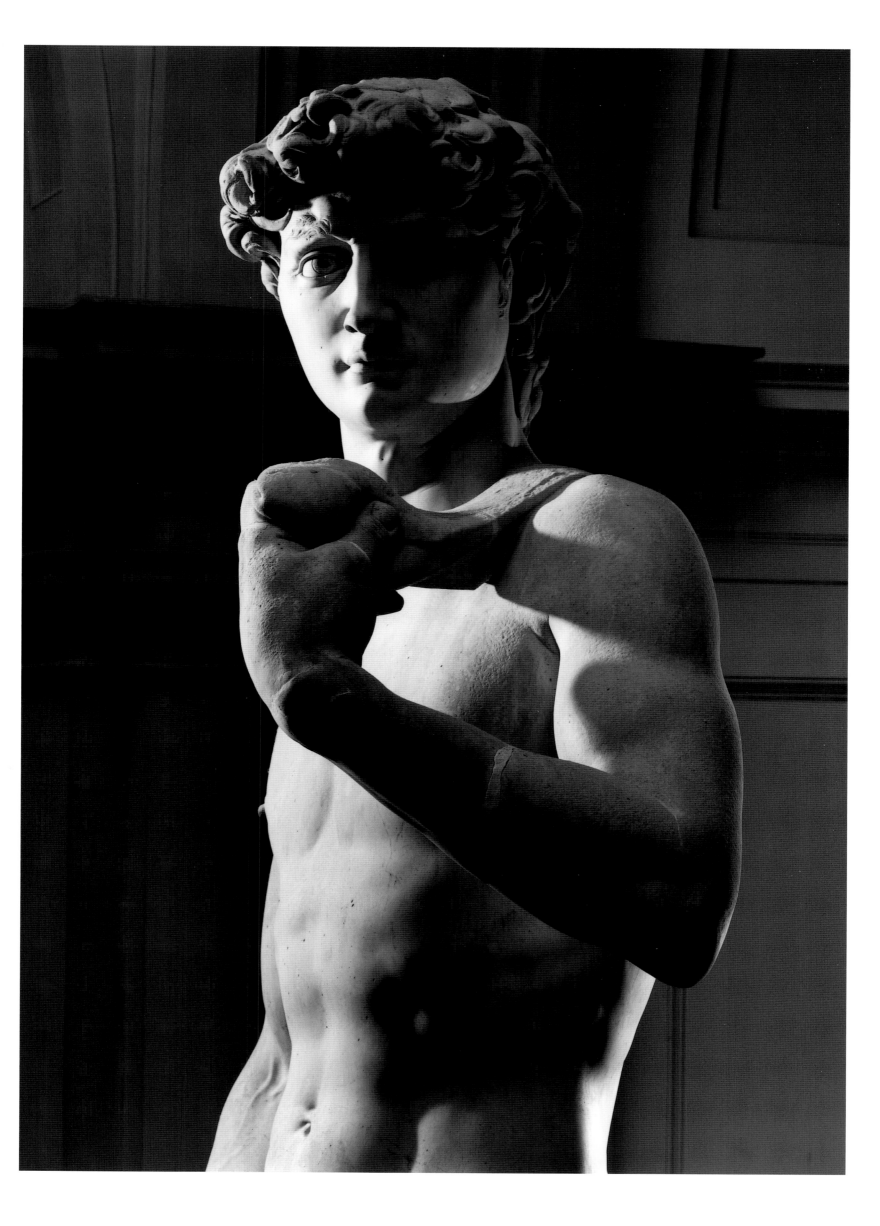

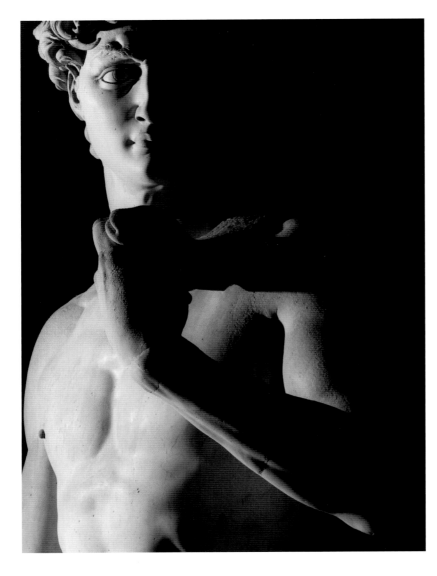

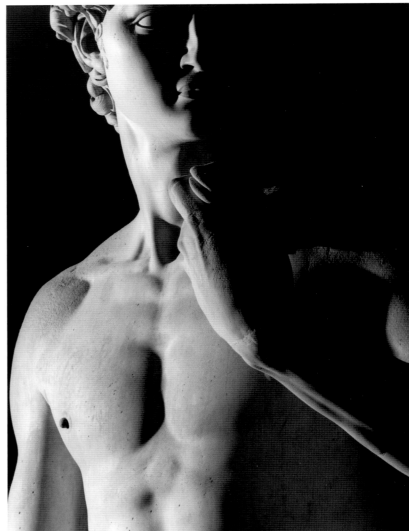

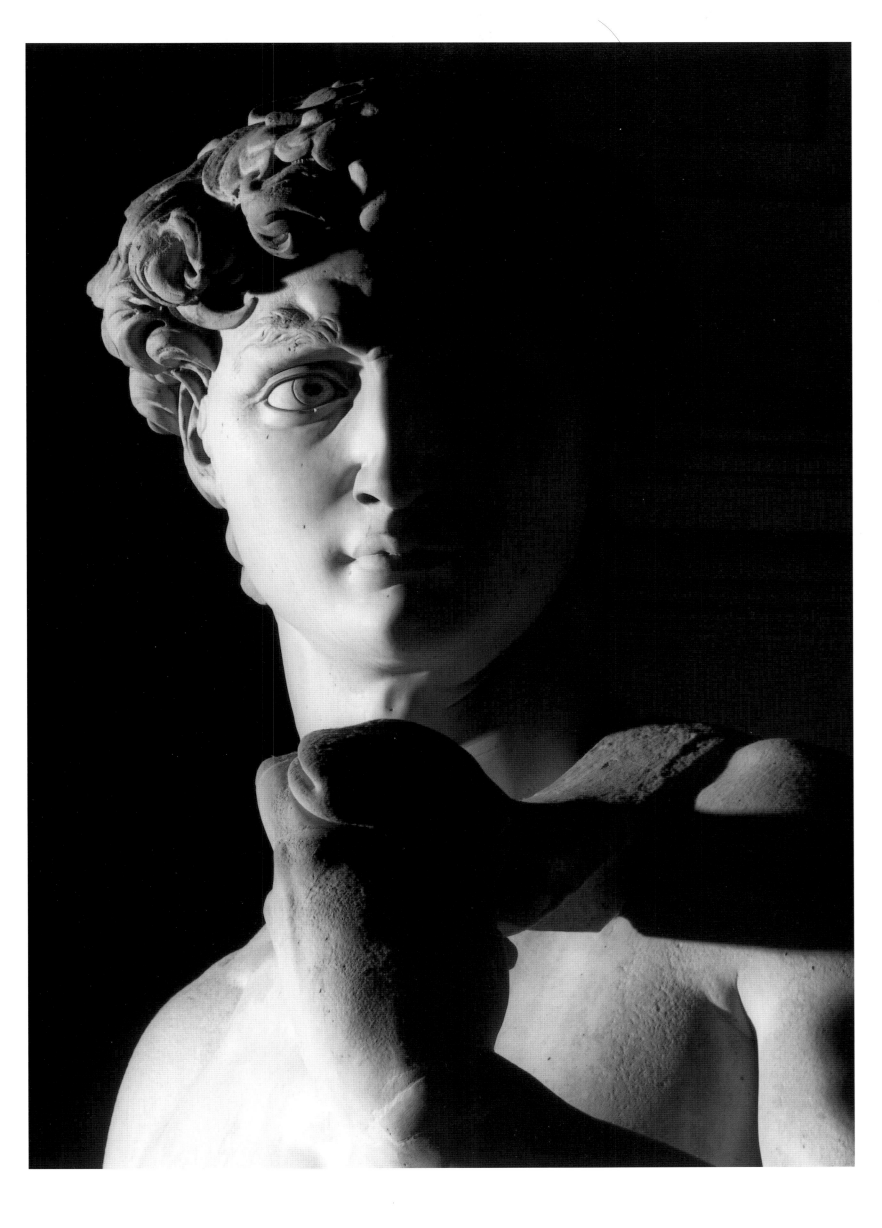

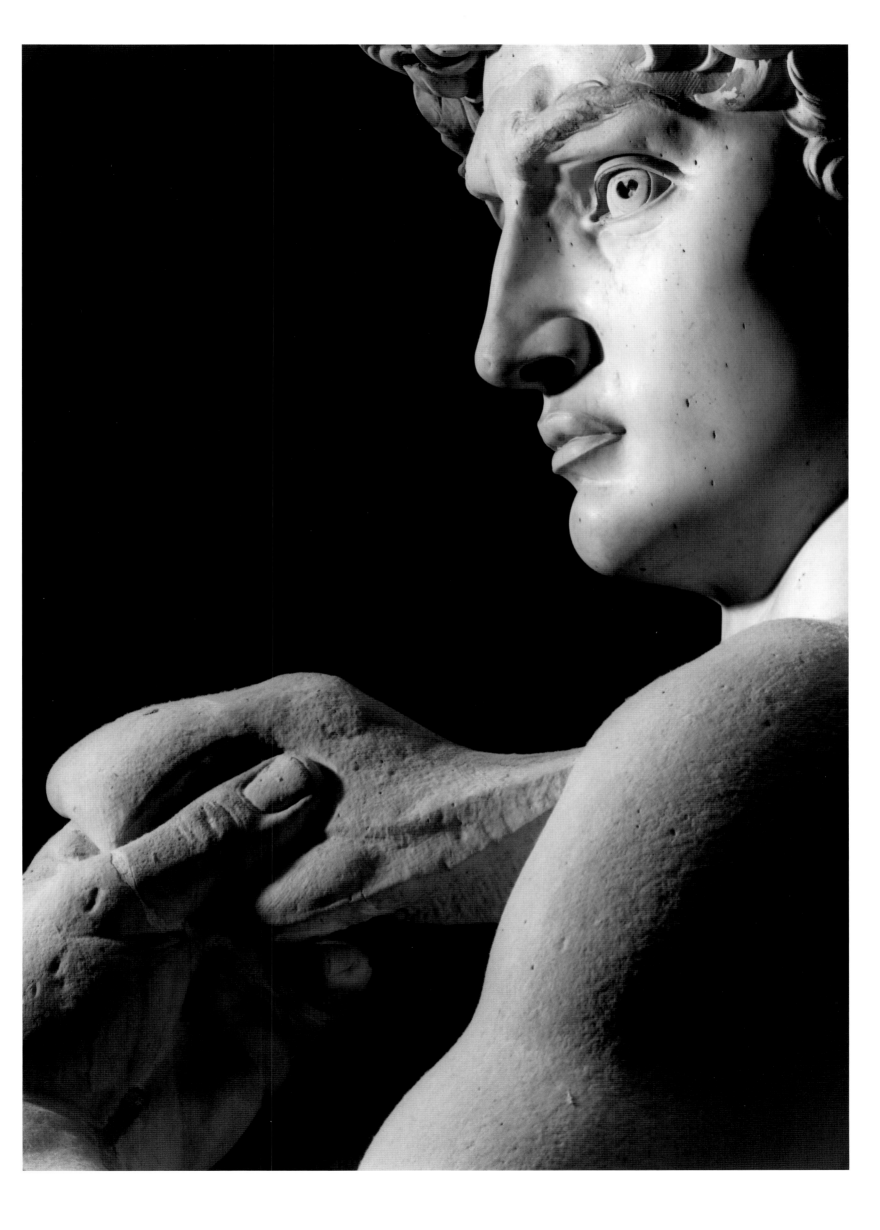

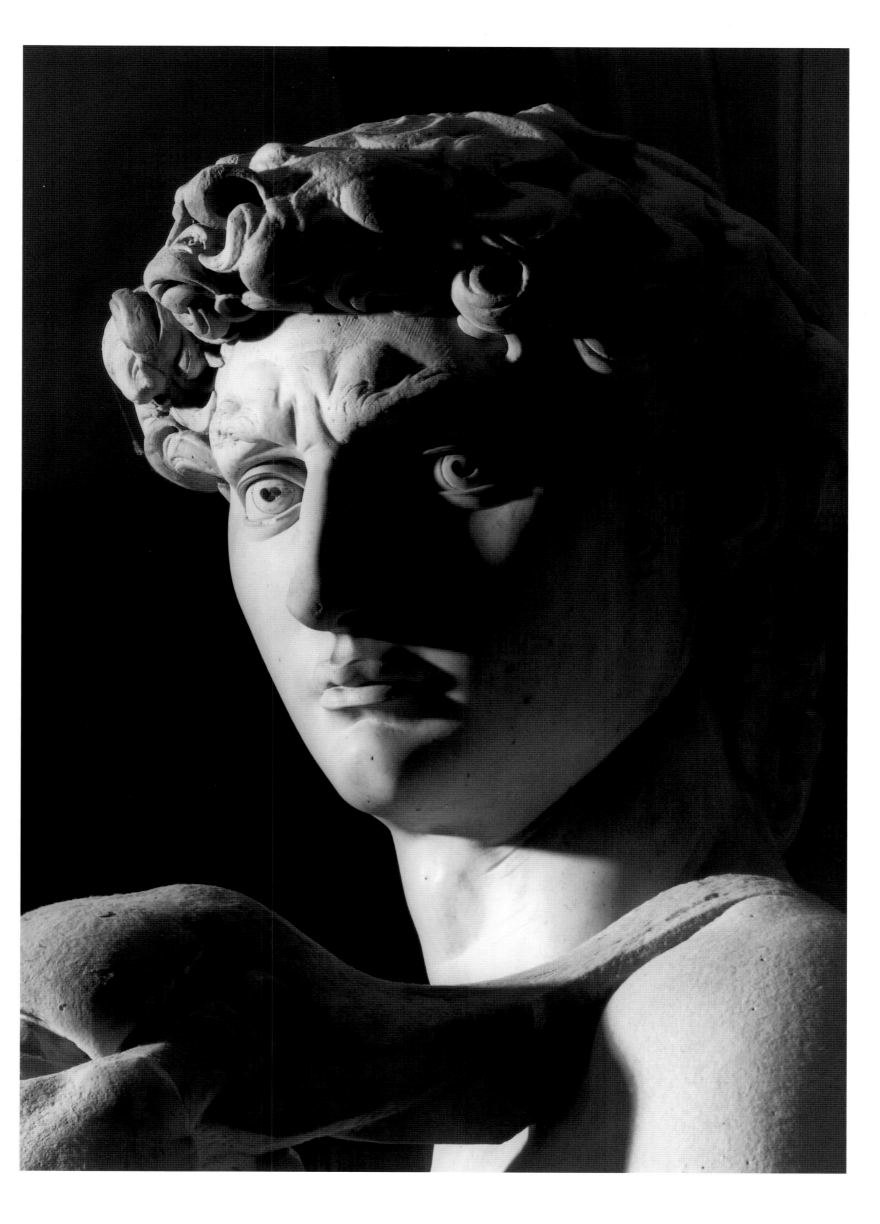

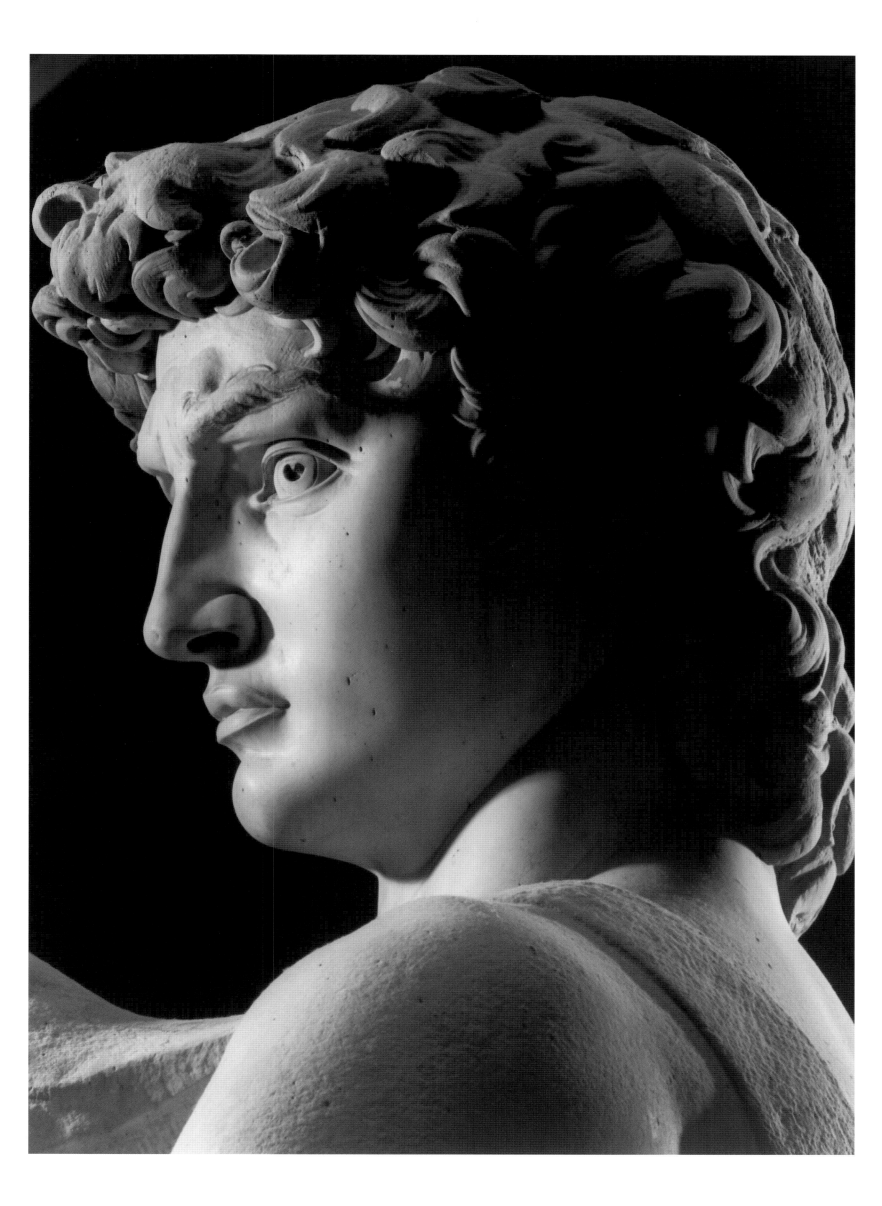

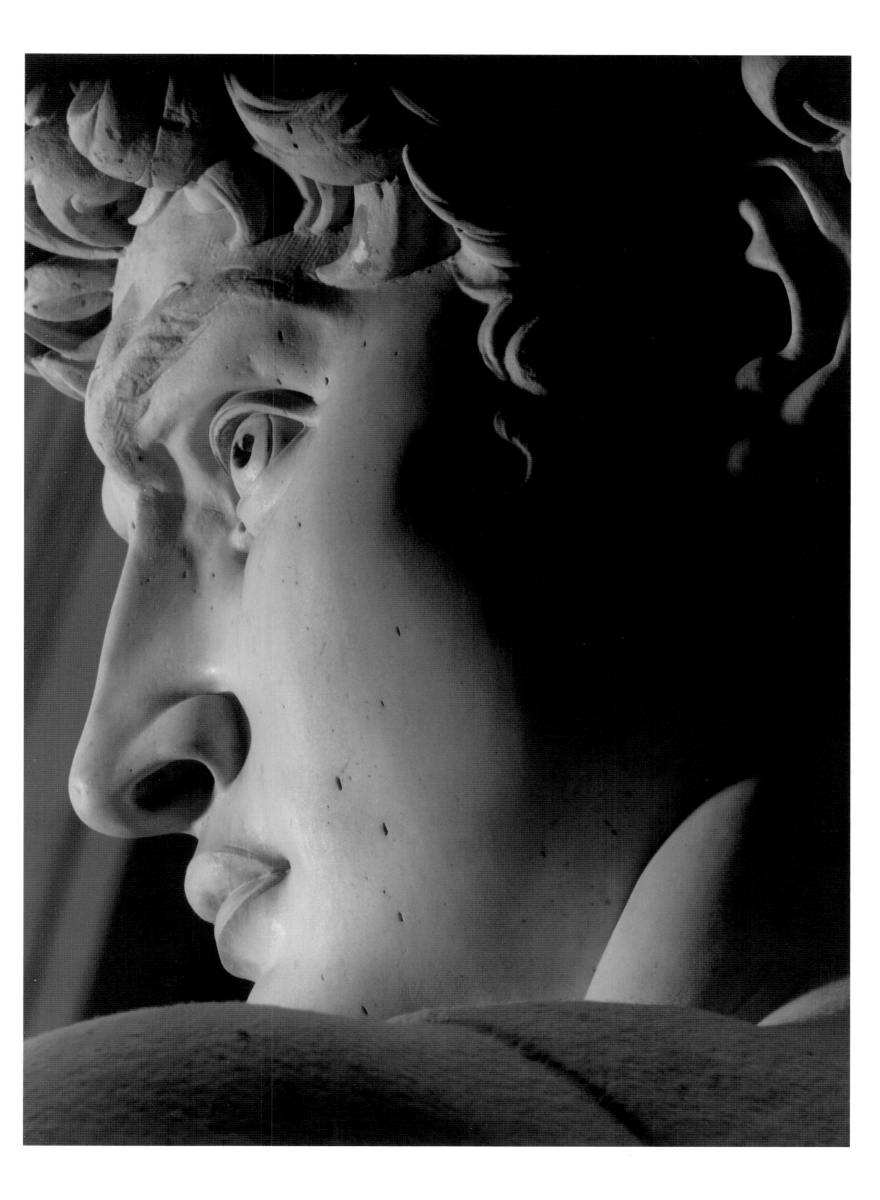

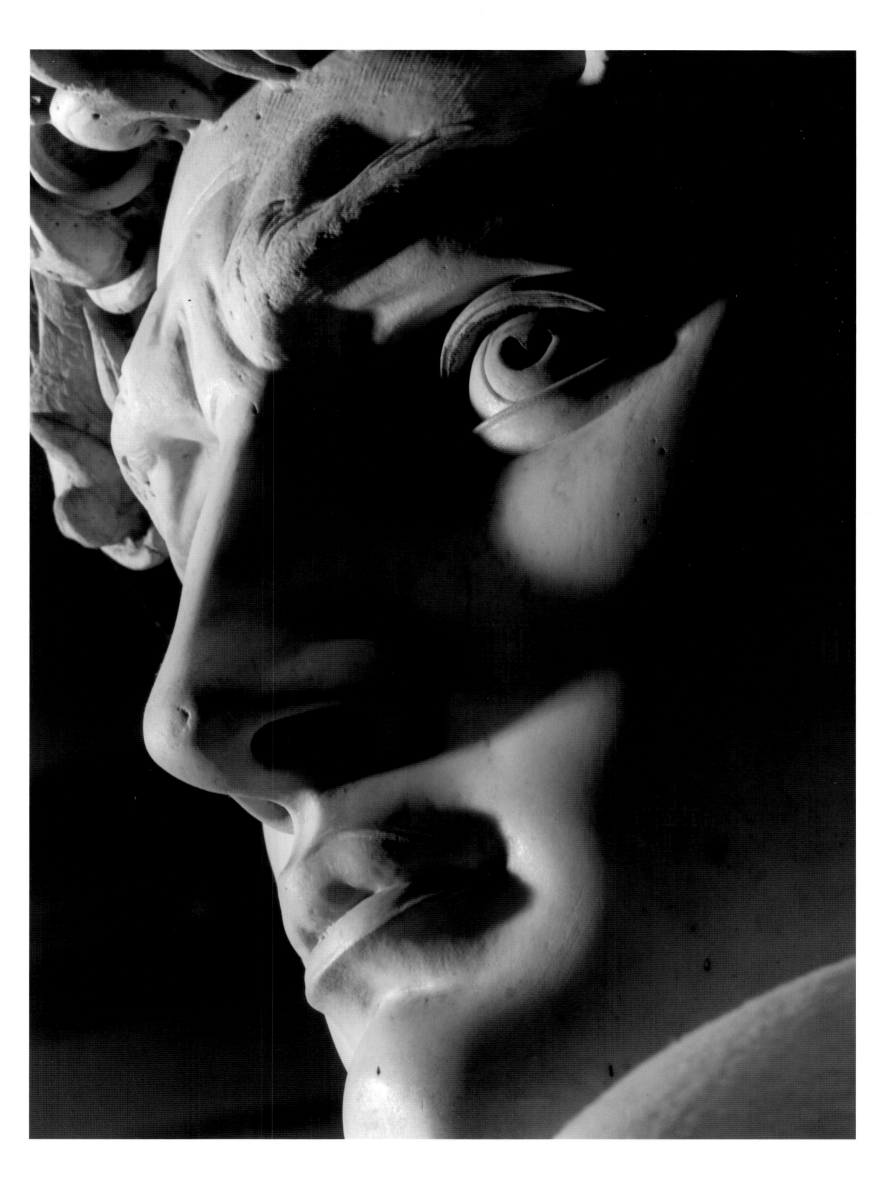

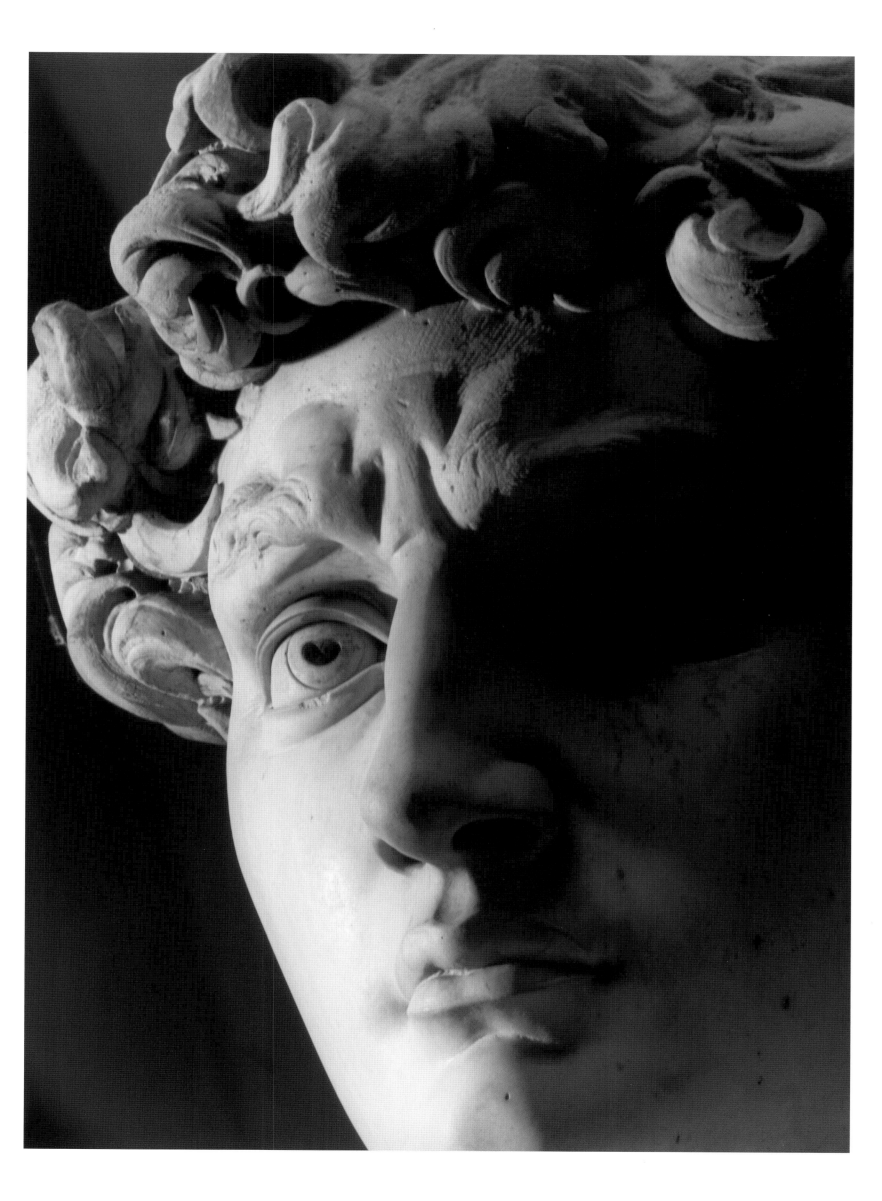

ANTONIO PAOLUCCI

After directing the Soprintendenza per i Beni Artistici e Storici del Veneto, the Beni Artistici e Storici di Mantua and the Opificio delle Pietre Dure and the Laboratori di Restauro di Firenze, Antonio Paolucci was appointed to his current post as Soprintendente per i Beni Artistici e Storici di Firenze, Pistoia e Prato in 1988. In 1995–96 he served as Minister for the Beni Culturali in the government of Lamberto Dini. Editor of the journals *Paragone* and *Bolletino d'Arte*, he teaches at the universities of Florence and Siena. Since 1997 he has been chairman of the Accademia di Belle Arti di Carrara. He has published numerous monographs (on Piero della Francesca and Antoniazzo Romano among others) and has contributed to *Avvenire*, *La Repubblica*, *Il Sole 24 Ore*, *La Nazione* and *Il Giornale dell'Arte*. He has curated various exhibitions and sections of exhibitions, including most notably 'Masaccio e il suo tempo' at the Palazzo Vecchio in Florence (1990) and 'The Renaissance' at the Scuderie del Quirinale in Rome (2001).

AURELIO AMENDOLA

Throughout his long career Aurelio Amendola has specialised in photographing works of art. In 1994 he was awarded the Premio Oscar Goldoni for his book *Un occhio su Michelangelo*. In 1995 an exhibition based on this same theme was held at the Palazzo Reale in Milan. His other publications include *Bernini: La Scultura in San Pietro* and *San Pietro*, an important photographic project to accompany the last text of the late Bruno Contardi. In 2003 he took a series of photographs for Jack Wasserman's study of Michelangelo's *Pietà*.